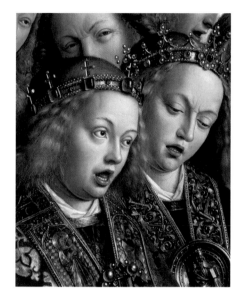

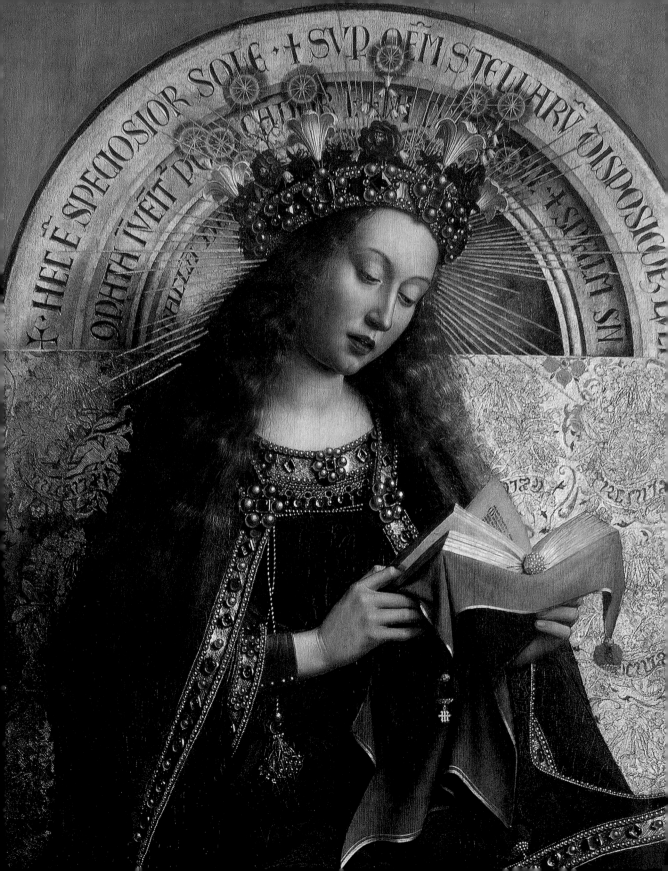

Till-Holger Borchert

JAN VAN EYCK

TASCHEN

HONG KONG KÖLN LONDON LOS ANGELES MADRID PARIS TOKYO

FRONT COVER:
The Arnolfini Marriage (detail), 1434
Oil on panel, 81.8 x 59.7 cm
London, The National Gallery

BACK COVER:
A Man in a Turban (Self-portrait?) (detail), 1433
Oil on panel, 33.3 x 25.8 cm (with frame)
London, The National Gallery

ILLUSTRATION PAGE 1:
The Ghent Altarpiece, open, 1432
Jan and Hubert van Eyck and Workshop
Singing Angels (detail)
Oil on panel, 161.7 x 69.3 cm
Ghent, St Bavo's Cathedral

ILLUSTRATION PAGE 2:
The Ghent Altarpiece, open, 1432
Jan and Hubert van Eyck and Workshop
The Virgin (detail)
Oil on panel, 166.7 x 72.3 cm
Ghent, St Bavo's Cathedral

© 2008 TASCHEN GmbH
Hohenzollernring 53, D–50672 Köln
www.taschen.com

Project management: Petra Lamers-Schütze, Cologne
Coordination: Christine Fellhauer, Cologne
Translation from German: Karen Williams, Rennes-le-Château
Production: Tina Ciborowius, Cologne
Layout: Claudia Frey, Cologne
Cover design: Claudia Frey, Cologne

Printed in Germany
ISBN: 978-3-8228-5687-1

Contents

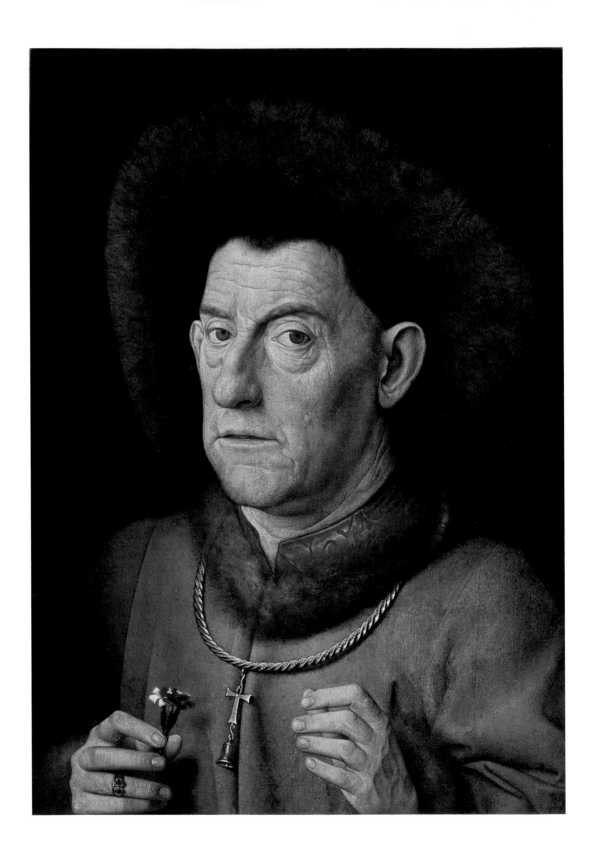

Jan van Eyck – Biography and Origins

The Florentine painter and historiographer Giorgio Vasari, the "father of art history", credits Jan van Eyck with one of the most fundamental innovations in painting. In the first edition of his *Lives of the Artists* (1550), we are told that Jan van Eyck invented oil painting. This information is offered at the start of the Life of the Italian artist Antonello da Messina, whose paintings testify to an intensive study of van Eyck's work. Vasari describes how van Eyck accidentally discovered that oils made suitable binders for pigments. He guarded his invention jealously and only revealed his secret to his closest pupils. According to Vasari, Antonello left Italy and travelled to the Netherlands for the express purpose of learning the mysteries of oil painting from van Eyck; there he was indeed initiated into the new technique and subsequently introduced it to Italy.

The Flemish painter and writer Carel van Mander (1548–1606), who styled Jan van Eyck and his brother Hubert the founders of Netherlandish art, took up the story in his *Schilderboek* (1604): Jan van Eyck, according to van Mander, worked initially in tempera, which he glazed with a varnish mixed from oils. While drying a varnished panel in the sun one day, the wooden joins separated and ruined the picture. Van Eyck consequently began looking for ways to speed up the drying process and discovered by way of experiment that linseed and walnut oil produced a fast-drying varnish. He added other materials to the oils, and found that pigments could also be dispersed and blended in them to achieve a more polished surface.

The legend that Jan van Eyck was the inventor of oil painting even found its way into Denis Diderot and Jean le Rond d'Alembert's *Encylopédie*, published between 1751 and 1780. It was Gotthold Ephraim Lessing (1729–1781) who finally consigned this invention of oil painting to the realm of myth: Lessing had discovered the treatise on painting written in the High Middle Ages by Theophilus Presbyter, in which the use of oils as binders is already described. In his study *Vom Alter der Ölmalerey aus dem Theophilus Presbyter* (1774), he proved that the technique of oil painting was already practiced long before van Eyck; at the same time, however, he wondered whether the legend might not conceal a kernel of truth and whether the painter was not responsible for qualitative innovations in this technique. Painting experts are still trying to unlock the secrets of van Eyck's technique even today.

Overall, the life and work of the artist, who died in 1441, still remain shrouded in mystery. Although famed and frequently copied far beyond the bounds of the

The Miracle in the Storm, c. 1435–1440
Turin-Milan Hours
Tempera on parchment, 29 x 19 cm
Turin, Biblioteca Nazionale Universitaria
(destroyed by fire)

Jan van Eyck's miniatures are distinguished by an understanding of landscape and spatial depth that was particularly advanced for its day. The compositional schemata employed here do not reappear until the Dutch genre and landscape painting of the 17th century.

ILLUSTRATION PAGE 6:
Jan van Eyck (copy)
Portrait of a Man with a Carnation, c. 1480
Oil on panel, 41.5 x 31.5 cm
Berlin, Staatliche Museen zu Berlin,
Gemäldegalerie

Niccolò Colantonio and Workshop
The Resurrection of Christ and the Three Marys at the Tomb, c. 1460
Oil on panel, 40.6 x 24.1 cm
New York, private collection

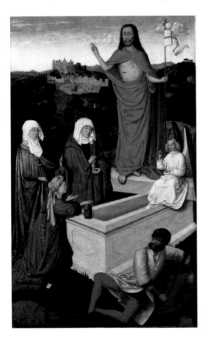

Netherlands during his lifetime, details of his career and œuvre are hazy. Neither the year nor the place of his birth is documented, and his artistic training and the larger part of his professional career are entirely shrouded in darkness.

Only in the late 16th century would Marcus van Vaernewyck and Lucas de Heere of Ghent record that Jan van Eyck was "born in Maesheyck". In view of the etymological derivation of his surname, which means "from Eyck", this information appears reliable. Moreover, the notes made by the painter on his *Portrait Drawing of Niccolò Albergati* (p. 42) are written in the local Maasland dialect; finally, the fact that Jan's daughter Lievine entered a nunnery in Maaseyck after his death in 1449 similarly seems to confirm this as his place of origin. Jan van Eyck's year of birth should be placed around 1390.

Between 1422 and 1425 he is documented in records from the Holland treasurer's office and in 1424 is specifically mentioned as court painter. "Meyster Jan den maelre" (Master Jan the painter) and his assistants were presumably engaged on a large programme of decorations and wall-paintings for the "Binnenhof", the palace of the Counts of Holland in The Hague. Holland was at that time governed by a branch of the German house of Wittelsbach, with the throne occupied since 1418 by John of Bavaria-Straubing (1374–1425) as Count of Holland and Zeeland. It is unclear when and under what circumstances van Eyck entered the service of the Wittelsbachs. In 1389 John of Bavaria was elected prince bishop of Liège, within whose territory lay Maaseyck; it is possible that, while there, he spotted the young Jan van Eyck and subsequently took him back to The Hague.

No more than traces survive of Jan van Eyck's activity during this period in Holland. The lost original of the *Portrait of a Man with a Carnation* (p. 6), for instance, shows the insignia of the Order of St Anthony funded by the Wittelsbachs. A number of miniatures from the so-called *Turin-Milan Hours* similarly include references to the Wittelsbach rulers of Holland and Hainault. Lastly, the allegorical watercolour drawing of a hunting and fishing party made up of members of the court of Holland, Bavaria and Brabant probably also goes back to a lost original by van Eyck (p. 10).

Immediately after the death of John of Bavaria (6 January 1425), van Eyck left The Hague and went to Bruges, at that time the most important centre of commerce in northwest Europe. Jan van Eyck was appointed court painter in the personal service of Philip the Good, Duke of Burgundy. This court appointment required the painter's presence whenever and wherever the Duke desired, and first entailed a move to Lille, the administrative centre of the Burgundian Netherlands.

In contrast to other court artists employed by Philip the Good, whose activities were linked to specific palaces – Dijon, Hesdin, Lille – and who produced for the most part coats-of-arms, banners and ephemeral decorations for tournaments and festivals, Jan van Eyck was entrusted right from the start with special and, as the documents put it, "secret" commissions. Of his normal, everyday duties, remunerated with an annual salary, nothing is known. His "special" duties, on the other hand, included "secret", today still mysterious journeys that Jan van Eyck undertook as the envoy of the ducal court between 1426 and 1429, and again in 1436: for each of these trips he received an emolument equal to several times his annual wage. In 1426 he departed, on behalf of the Duke, for "certain distant lands" – possibly a pilgrimage and voyage of discovery to the Holy Land, a suggestion lent weight by the topographical accuracy of the views of Jerusalem in paintings by van Eyck's workshop (p. 9). The only journey whose destination is known is that of 1428–1429, when he participated in a Burgundian delegation to Spain and Portugal to negotiate the marriage of Philip the Good and Isabella of

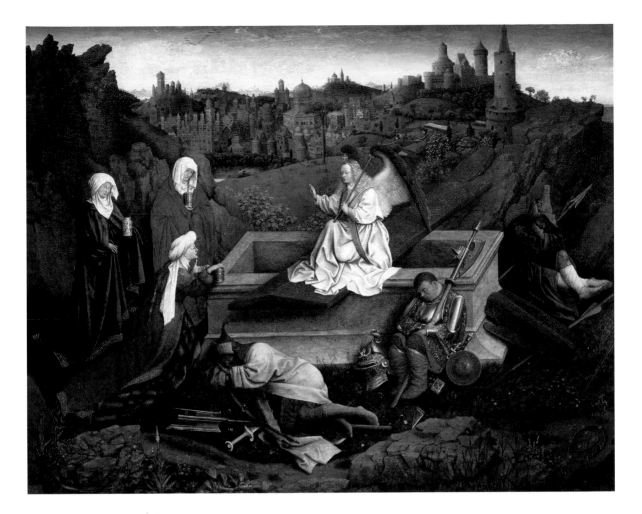

Jan van Eyck's Workshop
The Three Marys at the Tomb, c. 1440
Oil on panel, 71.5 x 90 cm
Rotterdam, Museum Boijmans Van Beuningen

Portugal. During this trip, Jan van Eyck portrayed of the Portuguese princess on two canvas, which were sent back to her Burgundian suitor by sea and land; it is likely that he had already taken with him a portrait of the bridegroom.

Jan van Eyck travelled regularly between 1425 and 1432; these travels were not solely connected with his court duties and did not always take him far. Thus on 18 October 1427, the Feast of St Luke (the patron saint of painters), he was invited to Tournai to attend a banquet in his honour by the local guild of artists, at which Robert Campin and Rogier van der Weyden were probably both present.

After his return from Portugal, Jan van Eyck was primarily occupied with the completion of *The Ghent Altarpiece* (chap. 2), that was installed and consecrated on 6 May 1432 in St Bavo's (at that time still the Sint Janskerk, or St John's Church). The quatrain on a silver strip mounted on the frame stated that Hubert van Eyck began this work at the behest of the Ghent patrician Joos Vijd and his wife Elisabeth Borluut. A "Master Hubert" was active in Ghent and died in 1426; on the basis of the quatrain and the early writings of Marcus van Vaernewyck, Lucas de Heere and Carel van Mander, the altar was thought to have been started by Hubert van Eyck and completed by his presumed younger brother Jan. Burgundian court records of the period mention another brother, Lambert van

Eyck, who – as evinced by an inscription on a copy of a lost *Portrait of Jacoba of Bavaria* (p. 11) – was also active as a painter and is documented in 1431. The fact that Marcus van Vaernewyck also records a sister, Margarete, as being a painter may be taken to indicate that Jan came from a family of artists, whose members may well have included Barthélémy d'Eyck, who later worked for René d'Anjou.

Jan's move from Lille to Bruges followed the completion of *The Ghent Altarpiece* (chap. 2) and marked a new chapter in the artist's career. Since van Eyck made annual mortgage payments for his house to St Donatian's church in Bruges from 1432 onwards, it seems likely that he had settled permanently in Bruges, where he installed his workshop. The Bruges councillors paid an official visit to his studio that same year and bestowed generous tips on his assistants. Van Eyck nevertheless had to continue to serve the Duke, whenever and wherever required. Thus the latter summoned him, still in 1432, to his residence in Hesdin, where the artist spent several weeks producing wall-paintings.

Van Eyck's move to Bruges seems to have marked a turning point in his private life, too: in around 1433 he seems to have married Margarete. She is described in Burgundian documents as "damoiselle Marguerite", whereby "damoiselle" may imply that she was of noble descendence. Certainly, her portrait at the age of 33 that Jan van Eyck painted in 1439 (p. 36) shows her dressed in the fashions of the aristocracy and thus illustrates the elevated social status of the painter and his wife. In 1434 their first child was born; in line with courtly convention, Philip the Good was godfather and on the occasion of the christening presented the painter with six silver goblets. That same year the artist completed *The Arnolfini Marriage* (p. 45), and was commissioned to paint the commemorative altarpiece for the Bruges canon *Joris van der Paele* (pp. 54–55).

Copy after Jan van Eyck
Allegorical Fishing Scene, c. 1550
Pen and watercolour with gold and white highlights on paper, 24.4 x 38.8 cm
Paris, Musée du Louvre

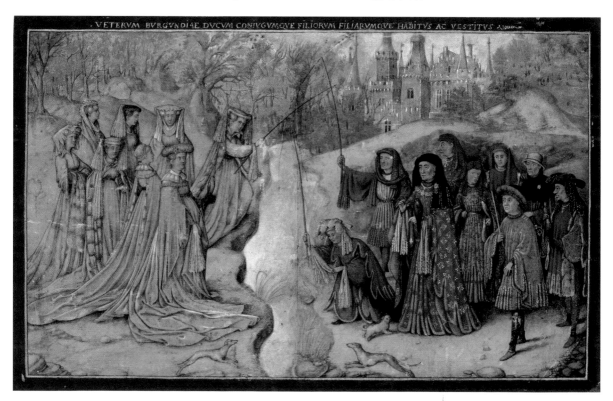

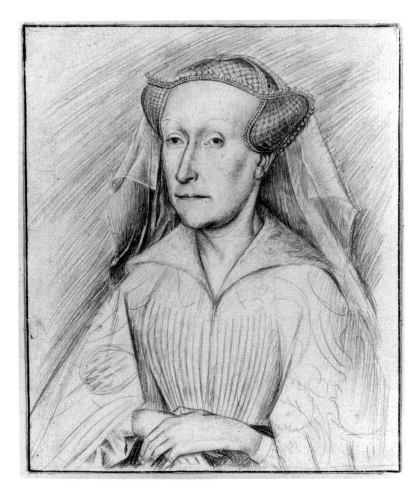

Copy after Lambert van Eyck
Portrait of Jacoba of Bavaria, c. 1455–1460
Silverpoint on prepared paper, 15.2 x 12.4 cm
Frankfurt am Main, Städelsches Kunstinstitut
and Städtische Galerie

The paintings that van Eyck produced in Bruges were predominantly private commissions; significantly, his annual salary was converted in 1435 into a lifelong pension and substantially increased. The treasurer's office in Lille at first refused to pay it, prompting the Duke to intervene personally: in a letter drawn up in Dijon on 13 March 1435, he demanded that his officials pay the money without delay to his esteemed valet de chambre and painter, of whose art and knowledge he stood in need. That same year he summoned Jan van Eyck to Arras, where the peace treaty between Burgundy, England and France was negotiated. It was there that van Eyck must have executed the portrait drawing of the papal legate and mediator *Niccolò Albergati* (p. 42).

In 1436 van Eyck undertook his last, richly remunerated mission on behalf of the Duke, one that took him to "foreign lands". The destination and purpose of his trip are unknown, but the journey fell within a period in which he produced several portraits and Marian paintings. Although van Eyck continued to execute panels for private clients, including Genoese and other Italian merchants, in the final years of his life he appears to have been also active as Philip's intermediary. In 1438, for example, he paid the Bruges miniaturist Jean Creve for illuminated initials for a manuscript destined for the Duke. In the winter of 1440, finally, he delivered "certain panels and other secret items" that he had acquired for his

Burgundian master. The payments he had made were reimbursed in January 1441, partly in addition to his pension in June. Van Eyck died on 9 July 1441. The following spring, at the request of Lambert van Eyck, the body of the esteemed painter was exhumed from the graveyard of St Donatian's in Bruges and laid to rest in a particularly privileged location inside the church.

Together with Jan's widow, Lambert van Eyck seems to have continued the Bruges workshop until 1450 (only in this year was van Eyck's house in Bruges finally sold). The widow and children received the Duke's financial support. As early as 24 July 1441, for example, Philip the Good granted "damoiselle Marguerite" the sum of "360 livres en 40 gros" – the artist's annual pension – in consideration of the services rendered by her deceased husband and as a gesture of condolence. In 1449 "Lyevine Van der Eecke" received, as a gift from the Duke, part of the dowry she needed to enter the nunnery of St Agnes in Maaseyck.

Barely 25 paintings can be securely attributed to Jan van Eyck, either on the basis of his signature or on other documentary and stylistic grounds. All of them were executed during the final decade of his career, after the completion of *The Ghent Altarpiece* (chap. 2) in 1432; works prior to this date are unknown. To this known œuvre, however, must be added some 20 – partly disputed – panel paintings, drawings and manuscript illuminations which reveal close parallels with Jan van Eyck's paintings or which are copies of lost works. While the majority of these "Eyckian apocrypha" are today considered to be products of the Bruges workshop, which continued to operate until 1450, earlier art historians saw in them youthful efforts by the master or even the works of Hubert van Eyck.

According to an inscription only rediscovered in 1825 on the original frame, it was Hubert van Eyck who began the famous *Ghent Altarpiece* and Jan van Eyck who completed. That the inscription praises "hubertus eeyck" as the artistically more important brother and ranks Jan van Eyck as second in the art is less a statement of fact than a gesture of modesty and conventional deference towards the elder artist, whose lasting renown would thus be secured. Nevertheless, the quatrain fuelled the curiosity of art historians of the 19th and early 20th century, who sought – entirely without success – for evidence of works by Hubert van Eyck. Even his existence was called into doubt, with some claiming that Hubert was invented in the 16th century by fiercely patriotic Ghent humanists, and that he was a fictitious character who had never actually lived, let alone been an important painter.

Although it is true that Hubert only appears in the annals of art history after the devastating Ghent Iconoclasm of 1566, Master "Hubrecht" and his assistants

are mentioned no less than four times in Ghent documents of the 15th century, the last occasion being an official record of Hubert's death in 1426. The earliest evidence dates from 1409, when "Master Hubert" was commissioned to paint an altarpiece for a religious institution for noble women in Tongeren. In the light of such documentary evidence, doubts about the veracity of the quatrain appear unjustified, at least as far as Hubert's person is concerned. This means, however, that Jan van Eyck's surviving œuvre made its late start – *The Ghent Altarpiece* of 1432 is his earliest secure work – under the shadow of his mysterious brother.

Eyckian art naturally did not appear out of nowhere, and both brothers were then already looking back on a successful painting career. The search for forerunners and artistic starting points is made enormously difficult, however, by the fact that so little art from this period has come down to us. The assumption that Hubert and Jan learned their craft in the family workshop in Maaseyck sheds no light on the foundations of their art, since almost no examples of Mosan art from around 1400 have remained today. The supposition, too, that Jan van Eyck worked in his early years alongside his elder brother suffices only to explain why it is impossible to distinguish their individual hands in *The Ghent Altarpiece*: as was standard practice in workshops of the day, they would have cultivated an identical style from which any personal nuance was deliberately eliminated.

The artistic milieu within which the brothers grew up can be glimpsed only in the *Norfolk Triptych* (p. 12). This small triptych, painted around 1415, depicts several saints venerated in the prince-bishopric of Liège, and can be therefore be localised to the van Eycks' native region. Both artistically and technically it is a work of great sophistication and presumably represents a commission of some importance. The delicate painting creates an effect of astonishing monumentality and demonstrates a stunning illusionism that foreshadows Jan van Eyck. For this reason the *Norfolk Triptych* is considered to shed light on van Eyck's stylistic origins, even though he did not author it. Its striking parallels with Jan's later paintings are themselves expressions of contemporary trends of illusionism and realism that, around 1400, had begun to emerge in works of art north of the Alps, not only in Mosan art.

In the search for van Eyck's roots, therefore, we must turn to the arts flourishing at the French courts in the late 14th and early 15th century. Heavily inspired by earlier Sienese and Provençal painters at the papal court in Avignon it survives, above all, in illuminated manuscripts. Miniatures then were a domain of artists such as Jacquemart de Hesdin, the Limburg brothers and the Boucicaut Master – the latter is probably identical to the illuminator Jacques Coene of Bruges who was active in Paris around 1400 (p. 13). Works of these miniaturists reveal early innovations in landscape, illusionism and spatial depth that influenced the creator of the *Norfolk Triptych*, and that reach their high point in the paintings of Jan (and Hubert) van Eyck. Although Jan van Eyck presumably knew these masterpieces of manuscript illumination (the princes of the Valois dynasty for whom such manuscripts were usually made also included the grandfather of Philip the Good), almost no direct links can be established between Eyckian painting and the works of Franco-Flemish miniaturists of the previous generation. Nor do any intermediary works survive that could document a gradual development from courtly manuscript illumination around 1400 to *The Ghent Altarpiece* of 1432.

The few extant Netherlandish panel paintings from the period before 1430 reveal closer affinity with miniature art and, as in the case of the altarpiece wings by Melchior Broederlam, were executed for the same high-ranking patrons. By contrast, those panels painted for Flemish civic authorities offer a rather provincial

Boucicaut Master (Jacques Coene)
The Visitation, c. 1415
Book of Hours of Maréchal de Boucicaut
Gouache on parchment, 27.5 x 19 cm
Paris, Institut de France – Musée Jacquemart-André (MJAP-MS 1311)

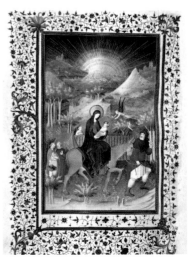

Boucicaut Master (Jacques Coene)
The Flight to Egypt, c. 1415
Book of Hours of Maréchal de Boucicaut
Gouache on parchment, 27.5 x 19 cm
Paris, Institut de France – Musée Jacquemart-André (MJAP-MS 1311)

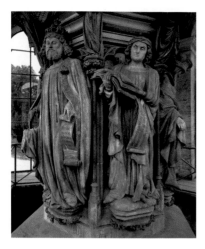

Claus Sluter
Prophets surrounding the Well of Moses, c. 1395
Sandstone, with fragments of polychrome paint-
ing, height ca. 200 cm
Dijon, Chartreuse de Champmol

Commissioned by the Duke of Burgundy for
the Charterhouse in Champmol, the sculptures
by the Haarlem artist Claus Sluter are important
forerunners of the realism found in the painting
of the van Eyck brothers.

ILLUSTRATION PAGE 15:
The Ghent Altarpiece, closed, 1432
Jan and Hubert van Eyck and Workshop
St John the Baptist (left)
Oil on panel, 146 x 51.8 cm
St John the Evangelist (right)
Oil on panel, 146.4 x 52.6 cm
Ghent, St Bavo's Cathedral

interpretation of the innovations achieved in courtly art. No examples survive of
wall-painting that decorated not only churches and monasteries, but also town
halls and ducal palaces. The appearance of such murals can perhaps be deduced
from the tapestry cycles that were woven to designs by manuscript illuminators
or panel painters in the looms of Flanders, Hainault and Artois. Yet, Flemish
tapestries from shortly after 1400, too, appear clumsy and stiff when compared
with both the works of van Eyck and with miniatures.

More interesting, on the other hand, is van Eyck's relationship to the sculpture
of the period around 1400. At its highest level, sculptors such as André Beauneveu
and Claus Sluter, as heads of large-scale workshops, created monumental works
that increasingly liberated themselves from the traditionally intrinsic links between
sculpture and architecture, and at the same time remained rooted in the networks
of masonries whose artisans – organised into specialised and mobile workshops –
built the great Gothic cathedrals.

Sluter and Beauneveu both were court artists who created sepulchral monu-
ments and realised architectural and sculptural projects for their royal patrons.
Sluter, who originated from Haarlem, headed the construction of the Carthusian
monastery of Champmol, near Dijon, for the Philip the Bold of Burgundy. There
he was in charge not only of the Duke's tomb, but also of the monumental figures
surrounding the so-called *Well of Moses* (p. 14). He was also responsible for the
decorations – completed posthumously by Sluter's son-in-law, Claus de Werve –
of the portal of the Chapel of Our Lady that featured the monumental statues of
the donor, Philip, and his wife Margaret of Flanders.

The surviving *Prophets surrounding the Well of Moses* – which was originally
crowned by a Calvary group and functioned as a well-head in the charterhouse
cloisters – seem as incomparable and unprecedented as *The Ghent Altarpiece*, yet
they were executed three decades earlier. The effort to individualise the facial
expressions shows the sculptor at pains to avoid repeating the idealised types of
earlier times in favour of distinct individuals: their bodies, too, are rendered with
a greater sense of plasticity. Attention has been paid to even the smallest details
of the draperies: the damask and brocade fabrics are carved with a feel for texture
that is equal to that of *The Ghent Altarpiece*.

Sluter's sculptures were originally painted and gilded, which must have height-
ened the realism of their appearance even further. Their polychromy, of which
the Burgundian court painters Jean Malouel and Henri Bellechose were in charge,
was part of their original concept. Such artistic collaboration between sculptors
and painters was common practice up till 1500 and it fuelled a stimulating ex-
change between the two artistic disciplines. Being a servant to one of the Dukes
of Burgundy himself, Jan van Eyck may well have known Sluter's sculptures and
drawn from them important inspiration for his own work.

Whatever the case, *The Ghent Altarpiece* reveals significant parallels with regards
to the plastic monumentality of the figures and the precise, detailed rendering
of sumptuous draperies, implying a close study of contemporary sculpture. In a
subtle manner, this exploration of sculpture by means of painting even becomes
the object of an artistic exercise in *The Ghent Altarpiece*: when viewed with its
shutters closed, the centre of the bottom register is occupied by the figures of
St John the Baptist and *St John the Evangelist* standing in *trompe-l'œil* niches
(p. 15). The two saints are not portrayed as flesh and blood but are ostentatiously
presented as stone sculptures with a smoothly polished and reflective surface –
yet without the painted polychrome exterior that the contemporary spectator
would have expected – for it was a given feature of such sculptures at that time.

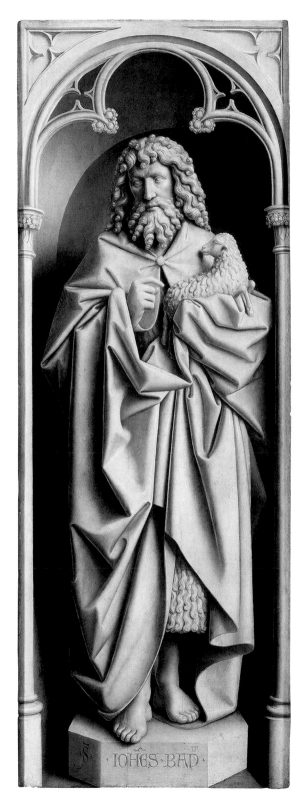
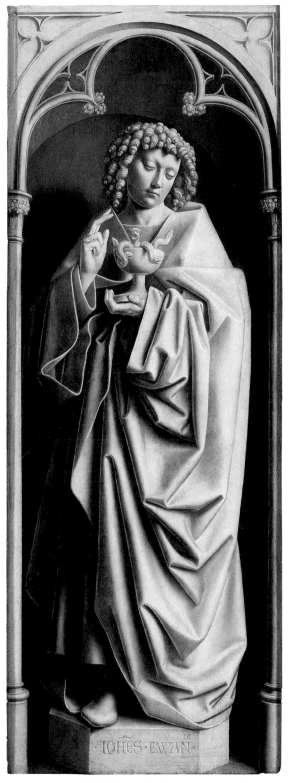

IOHES·BAP

IOHES·EWAN

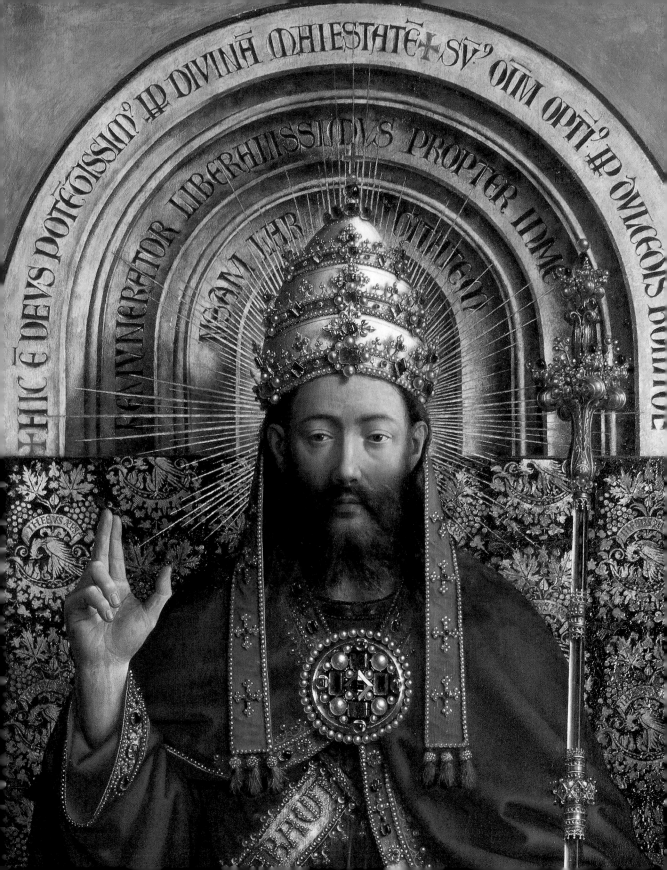

The Ghent Altarpiece

The Ghent Altarpiece is the largest, most multi-faceted and most complex work created by Jan van Eyck and his mysterious brother Hubert. Destined for St John's church (today St Bavo's Cathedral) in Ghent, it represents a founding work of Renaissance painting. Seemingly without precedent, the masterpiece illustrates – in 26 individual scenes across twelve panels – an encyclopaedic compendium of Christian theology, which links the beginning of the history of Salvation (*The Annunciation* on the outside) with its end (*The Adoration of the Lamb* of Revelation on the inside).

Both when closed, in its everyday position and open, its feast-day position, the altarpiece is divided into two horizontal zones, which establish a formal division between different thematic areas. This strict separation of upper and lower register, together with the striking discrepancy in their respective figure scale, for a long time obscured the logical cohesion of *The Ghent Altarpiece's representation*. It was even wrongly suggested that the retable represented a compilation of originally independent altarpieces that were only later combined.

The themes selected for the open, feast-day interior relate dedication of the altar to "All Saints" for which the retable was destined (pp. 18–19). Overall, the lower register portrays a continuous succession of all saints: on the central panel the confessors, martyrs and saints together with the prophets and patriarchs, and on the wings *The Righteous Judges*, *The Soldiers of Christ*, *The Hermits* and *The Christian Pilgrims*. All but the *Soldiers*, *Judges* and *Pilgrims* are a fixture of medieval All Saints sermons and are described by Jacobus de Voragine in his *Golden Legend*. The untold numbers of saints – of whom only a very few can be identified by their attributes – clearly illustrate the community of the blessed to whom Paradise is promised. They are situated in a paradisiacal landscape with glimpses of cities in the background. The whole offers a vision of the New Jerusalem, as described in Revelation and, for example, in the writings of St Augustine.

The lower zone can therefore be read at the same time as an illustration of Revelation, traditionally associated in mediaeval art with the All Saints iconography of the *chori beatorum*, a mystical assembly of the blessed. On an altar in the centre stands the apocalyptic Lamb, from whose breast blood flows into a sacrificial chalice. The Lamb is the object of worship of the saints approaching from all four points of the compass and the symbol of Christ and his death and Resurrection. Ostentatiously, the sacrament of the Eucharist in the celebration of

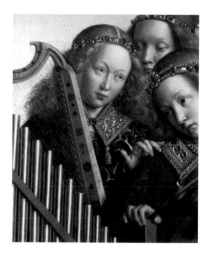

The Ghent Altarpiece, open, 1432
Jan and Hubert van Eyck and Workshop
Music-making Angels (detail)
Oil on panel, 161.1 x 69.3 cm
Ghent, St Bavo's Cathedral

ILLUSTRATION PAGE 16:
The Ghent Altarpiece, open, 1432
Jan and Hubert van Eyck and Workshop
God the Father (detail)
Oil on panel, 210.5 x 80 cm
Ghent, St Bavo's Cathedral

The interpretation of the impressive divinity in the centre of *The Ghent Altarpiece* remains a matter of debate even today. It is unclear whether the figure is intended to represent Christ or God the Father. This ambiguity is possibly a reflection of contemporary theological discussions on the nature of the Trinity.

"Of the Early Netherlandish artists, for example, van Eyck has achieved, in his God the Father in the altarpiece in Ghent, the greatest heights that it is possible to attain in this sphere; it is a work that can stand alongside the Olympian Jupiter."

GEORG FRIEDRICH WILHELM HEGEL, 1842

Jan and Hubert van Eyck and Workshop
The Ghent Altarpiece, open, 1432
Oil on panel, 375 x 520 cm
Ghent, St Bavo's Cathedral

18

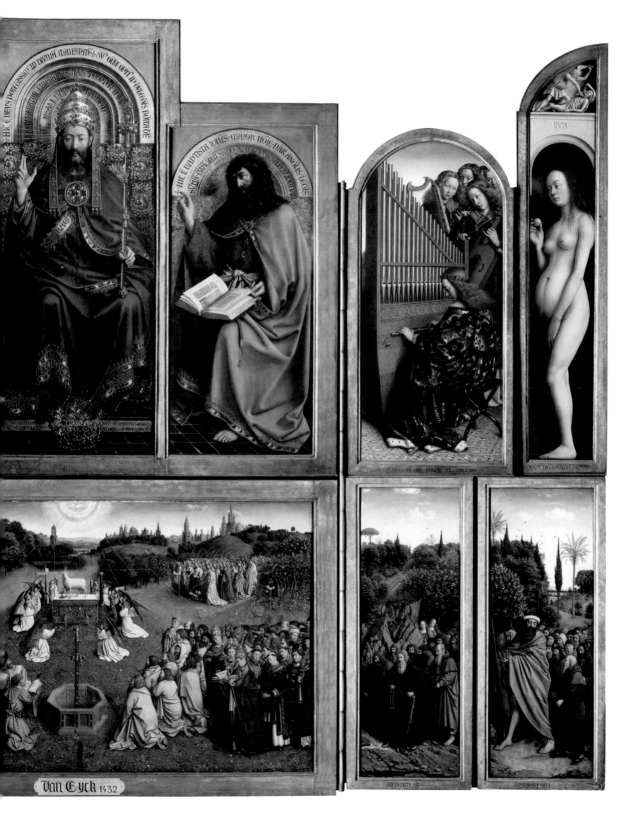

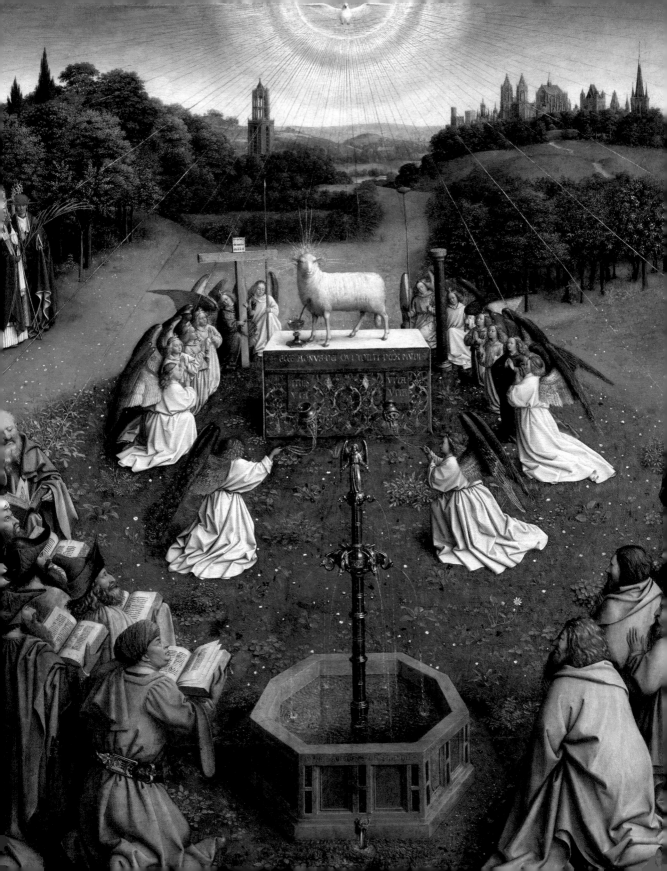

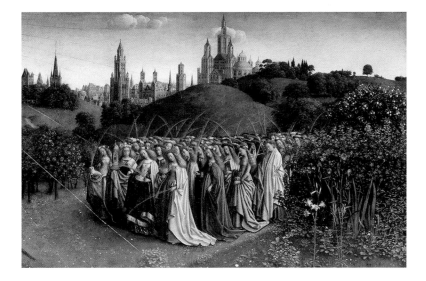

Mass is emphasised, and thus the promise of salvation offered in the New Testament is underlined, by the motif of the angels around the Lamb: they present the instruments of the Passion and, like priests, swing incense burners.

Above the Lamb we see the dove of the Holy Ghost, hovering in front of a kind of sun. This sun is the symbol of divine light, since the New Jerusalem of Revelation "had no need of the sun, neither of the moon, to shine in it; for the glory of God did lighten it" (Rev. 21:23). Golden beams radiate out from it, illuminating both the landscape and in particular the saints approaching from all sides.

In front of the Lamb stands the fountain of life (Rev. 22:1), symbol of the baptismal font. The foreground position of the fountain makes it clear that only those who receive the sacrament of baptism can participate in the Eucharist and thus in the redemption promised by Christ's Crucifixion. The water flowing out of the fountain feeds the "river of life" symbolizing the paradisiacal New Jerusalem. The river of life thereby runs down to the very bottom edge of the panel and appears to fall onto the real altar table below, in front of which Mass was celebrated. A concrete connection is thereby established for the faithful between their own practice of worship and the hope of salvation offered by the altarpiece's vision of Paradise. The need for redemption, as all contemporary viewers were permanently aware, had arisen with the Fall of Mankind, present here in the figures of *Adam* and *Eve* in the outermost panels of the upper register. The necessity of redemption was also a consequence of the sins committed by mankind since the expulsion from Paradise. This is shown by the two episodes from the story of *Cain* and *Abel* depicted in imitation sculptural reliefs in spandrels above *Adam* and *Eve*: they depict the rejection of *Cain's* offering of corn and his subsequent murder of *Abel* (pp. 22, 23).

According to Christian thought, Christ's incarnation and his death on the Cross promise salvation which finds its fulfilment in the celestial realm described in Revelation as following the resurrection of the dead and the Last Judgement. These events are alluded to as well: the Last Judgement preceding the advent of the New Jerusalem is visually present in the deësis group in the centre of the upper register, comprising *God the Father*, *The Virgin* and *St John the Baptist*. As crucial elements of the iconography of Last Judgements that in those days formed part

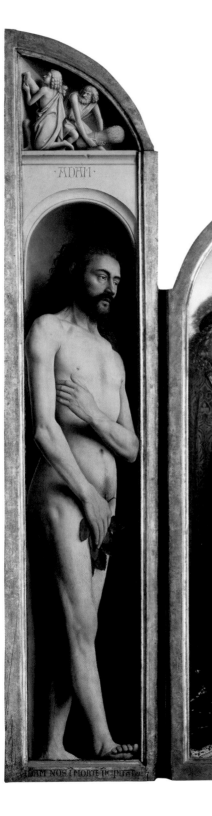

The Ghent Altarpiece, open, 1432
Jan van Eyck and Workshop
The Sacrifice of Cain and Abel; Adam
Oil on panel, 204.3 x 33.2 cm
Jan and Hubert van Eyck and Workshop
Singing Angels
Oil on panel, 161.7 x 69.3 cm
Ghent, St Bavo's Cathedral

The Ghent Altarpiece, open, 1432
Jan and Hubert van Eyck and Workshop
Music-making Angels
Oil on panel, 161.1 x 69.3 cm
Jan van Eyck and Workshop
Cain murders Abel; Eve
Oil on panel, 204.3 x 32.3 cm
Ghent, St Bavo's Cathedral

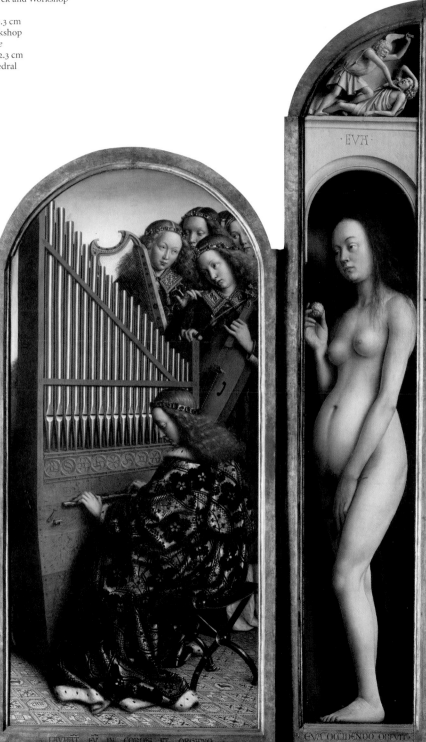

The Ghent Altarpiece, open, 1432
Jan and Hubert van Eyck and Workshop
God the Father (detail)
Oil on panel, 210.5 x 80 cm
Ghent, St Bavo's Cathedral

As early as the 16th century, restoration work was carried out on *The Ghent Altarpiece* by Lancelot Blondeel from Bruges and Jan van Scorel from Utrecht. In its present form, the magnificent crown at the feet of the divinity goes back to this restoration. It symbolizes God's dominion over the secular powers of the world.

ILLUSTRATION PAGE 25:
The Ghent Altarpiece, open, 1432
Jan and Hubert van Eyck and Workshop
St John the Baptist (detail)
Oil on panel, 162.2 x 72 cm
Ghent, St Bavo's Cathedral

of the standard décor of most Netherlandish town halls, their meaning would have been unmistakable. The monumental grandeur of the figures already indicates a different level of reality to that of the lower register. It is important to notice, however, that in its representation of *The Virgin* and *St John the Baptist*, *The Ghent Altarpiece* differs fundamentally from depictions of the Last Judgement – it relinquishes the motif of *intercessio*: contrary to pictorial convention, both figures are not shown interceding on behalf of the souls of the deceased, but are represented studying scripture. The crown on her head identifies *The Virgin* as the Queen of Heaven; she is characterised by verses from the Wisdom of Solomon – verses that also formed part of the prayers for the Office of the Assumption: "For she is more beautiful than the sun, and above all the order of stars… For she is the brightness of the everlasting light, the unspotted mirror of the power of God…" (Wis. 7:29/26). Latin inscriptions on the arches above *St John the Baptist* (p. 25) name the prophet "greater than man, equal to the angels, sum of the law, voice of the apostles, silence of the prophets, light of the world, witness of the Lord".

The figure of *St John the Baptist* deviates in another way from artistic convention insofar as his usual attribute of a lamb has been omitted – the motif already appearing at the centre of *The Adoration of the Lamb* below him. His pointed finger, gesturing towards the figure of divinity, thereby introduces an element of ambivalence. For whereas the Baptist usually points at Christ as the Lamb of God, the papal tiara is a symbol reserved for God the Father. The crown resting on the ground (p. 24) can be understood as a sign of the subordination of secular power to the sacred dominion of the divinity portrayed here as the apocalyptic King of Kings, who can represent both Christ and God the Father. The passages of text on the gilt arches, draperies and steps of the throne are also equivocal within the Trinitarian theology of the Late Middle Ages. It seems likely that the ambiguity of the central figure is the result of a conscious decision, one which reflects the contemporary debate over the nature of the Trinity at the time *The Ghent Altar* was painted. It is possible that this decision was preceded by detailed discussions between the patron, theologians and the artists. Whatever the case, the Trinity of God the Father, the Holy Ghost and the Lamb of God is prominently depicted along the central vertical axis of the altarpiece. On either side of the deësis in the upper register are choirs of *Singing* and *Music-making Angels* (pp. 22, 23). The majolica tiles – in those days imported into the Netherlands from Valencia – are decorated with the IHS monogram of Christ, the Greek alpha and omega as another abbreviation for Christ, and a stylised Lamb. The angels must be understood first and foremost as forming the retinue of the King of Kings, as described for example in *The Golden Legend*. They are cherubim, but are shown without wings; their magnificent robes recall liturgical chasubles, which in turn allude to the celebration of Mass in front of the altarpiece.

If the feast-day side of *The Ghent Altarpiece* represents the fulfilment of the plan for Christian salvation, with the advent of the celestial realm of the Heavenly Jerusalem, the closed altarpiece shows its beginning (p. 28). The lowest register consists of four niches containing the two donors and, in the form of imitation stone sculptures, *St John the Baptist* and *St John the Evangelist*. The upper zone depicts *The Annunciation*, set in a room inside a tower and spread across four panels. On the far left, Archangel Gabriel approaches the Virgin, who is kneeling at prayer on the right, the dove of the Holy Ghost above her head. The Archangel hails Mary with the words "Ave Maria"; her reply – "Ecce ancilla domini" (Behold,

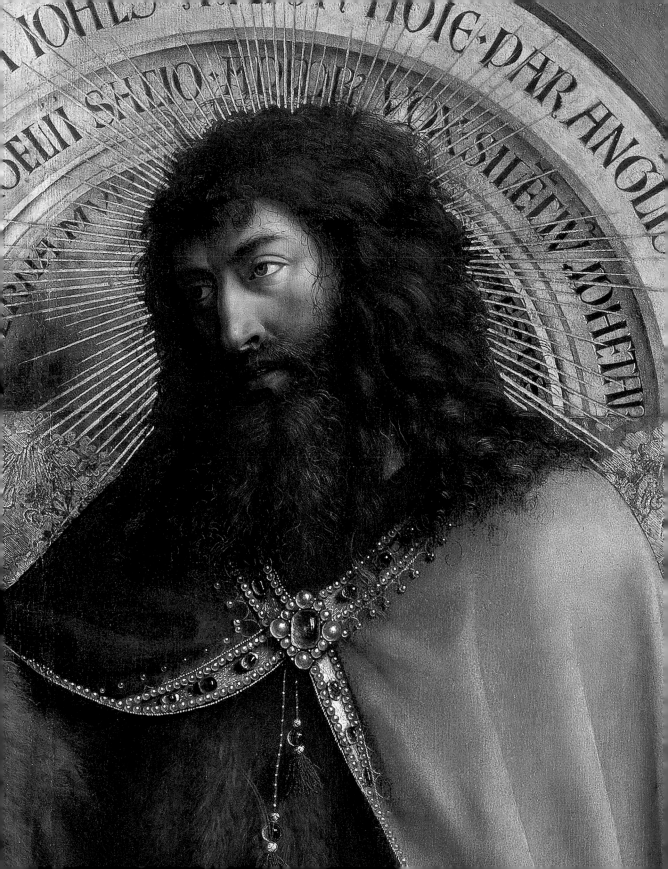

the handmaid of the Lord) – is written upside down, so that the prophets in the niche zone overhead can read it or so that it is addressed directly to the Holy Ghost.

Through the open arches of the windows one sees the building of a mediaeval town, whereby the biblical event is brought into the viewer's own world. The interior itself also contains still-life arrangements of everyday objects, albeit here lent allegorical significance. Thus the small glass bottle on the windowsill was a popular symbol of Mary's chastity, while the lavabo and ewer set into the niche resemble liturgical utensils. In this way the Virgin's significance as "Ecclesia", as the Church and altar of God, is underlined. In the top register, the Old Testament prophets *Micah* and *Zechariah* appear to the left and right of the *Cumaean* and *Erythraean Sibyls*. They seem to emerge from their painted spandrels as solid figures and are accompanied by banderoles whose inscriptions prophesy the coming of the Messiah as the future king of the world. This uppermost zone can be interpreted as heralding the promise of eventual redemption delivered with the Annunciation and fulfilled in the advent of the Kingdom of God on the interior of the altarpiece.

In terms of content, *The Ghent Altarpiece* is a highly sophisticated work that conveys its message of Christian salvation through the associations and ideas it evokes in the viewer. There can be no doubt that learned theologians, familiar not only with the Bible but also with its exegesis, advised its composition. Nevertheless, the influence of such scholars upon the final appearance of *The Ghent Altarpiece* should not be overestimated; their contribution may only have extended to individual motifs and typological antitheses. The composition as a whole and the *mise-en-scène* of its complex iconography are based upon artistic decisions. The intellectual ambition of the monumental altarpiece is paralleled at the artistic and technical level: the quality of the panels – despite certain restorations – is unrivalled, and details such as the magnificent liturgical robes, jewels and precious stones, the reflections on the gleaming armour and the botanical accuracy of the vegetation demonstrate an impressive mixture of mimetic talent, painterly precision and artistic efficiency.

The Ghent Altarpiece offers an entirely new view of reality that embraces both this world and the next, and which finds its expression in a previously unknown realism that extends even to the smallest details. This was only made possible, of course, by a perfect mastery of the materials and techniques of painting and by a deliberate observation and reflection of the visible world. In terms of its size, intensity and quality, the work confronts the viewer with innovations never seen before – innovations that remain compelling even today because they form the bases of our own, modern ways of seeing and of looking at art.

Here we find the first monumental figures in panel painting north of the Alps. With their faces depicted without embellishment, the naturalistic, nearly lifesize portraits of the donor and his wife leave the idealizing portraiture of earlier generations far behind; at the same time they overcome the symbolic use of scale in mediaeval art, according to which saints were shown as larger than ordinary people. The stylised interiors of art around 1400, with their deliberate spatial depth, have given way to everyday settings whose perspective convinces even today. Illusionistic elements are present not only in the skilful imitations of stone statues, but also in the *trompe-l'œil* pulpits across which the prophets, with their weighty codices, appear to be leaning out of the pictorial plane. Equally remarkable is the fact that the earlier gold ground has been replaced by a panoramic view of a natural or rather paradisiacal landscape, which extends across five panels and encompasses luxuriant and in places exotic vegetation, and painstakingly

The Ghent Altarpiece, open, 1432
Jan and Hubert van Eyck and Workshop
The Christian Pilgrims (left)
Oil on panel, 146.5 x 52.8 cm
The Hermits (right)
Oil on panel, 146.4 x 51.2 cm
Ghent, St Bavo's Cathedral

Worthy of note is the exotic vegetation in the background of the two panels of the pilgrims and the hermits. Had Jan van Eyck seen palms and cypresses on his "secret journeys to foreign lands", and incorporated these Mediterranean trees into the paradisaical landscape of his *Ghent Altarpiece*?

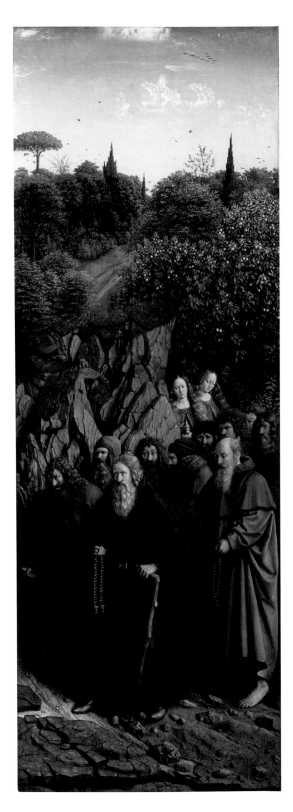
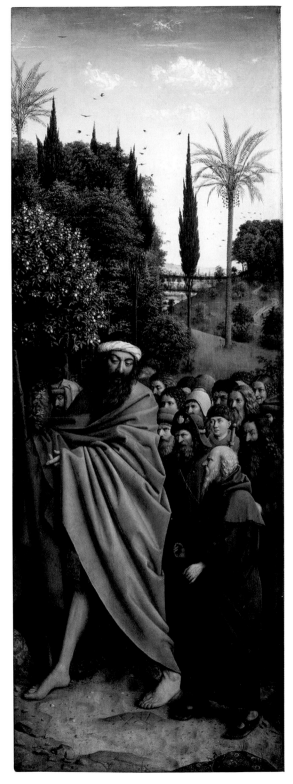

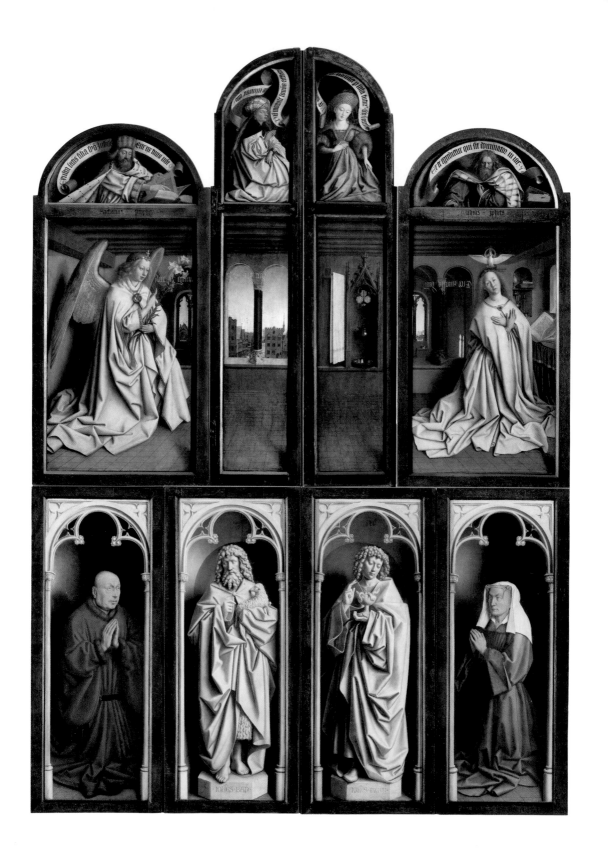

observed geological features. At the same time, aerial perspective – the increasing haziness of the distant background as later described by Leonardo da Vinci – makes its first appearance in European art. Alongside these ground-breaking innovations, another dazzling feature of the painting – one that contemporaries particularly admired – is the alchemical quality of its exquisitely delicate technique, which imitates jewels, damasks, silks and brocades in all their rich textures. None less than Albrecht Dürer, who visited Ghent in 1521 and saw the altarpiece, praised it in his diary as a "very splendid, deeply reasoned painting".

The Ghent Altarpiece still poses an enigma. How much of its design and execution can be attributed to Hubert van Eyck prior to his death in 1426, and how much of the work, completed in 1432, belongs to Jan? Neither iconographical analyses nor stylistic comparisons nor even modern methods of scientific investigation have brought us significantly closer to an answer. It remains a matter of contention even today.

Perhaps the problem arises out of our somewhat misguided notions of what it is to be an artist – notions rooted in the 19th century but irrelevant for 15th century art. If we examine the chronology of events, it becomes clear that it would have been impossible for Jan van Eyck to take over the unfinished altarpiece straight after Hubert's death. He had only entered the service of Philip the Good as valet de chambre the summer before and his presence at court was then indispensable; it is most unlikely, therefore, that he would have received permission to devote himself to a private commission. Besides, between 1426 and 1429 he undertook several journeys – including to Portugal as Philip's envoy – and so could hardly have spent much time in Flanders during this period. As court painter, moreover, his first duty was to carry out commissions requested of him by the Duke, which probably took up the remainder of his time. Only after his return from Portugal – at the end of 1429 – did Jan van Eyck return to Flanders for a lengthier period. Only now, and hence for a maximum of two years, could he have devoted himself in person to the completion of the altarpiece.

Naturally, work on *The Ghent Altar* did not resume only as from 1430. Jan van Eyck had had assistants at his disposal even in The Hague, and some of these may have accompanied him to Flanders. Hubert van Eyck's own Ghent workshop also employed assistants who – in line with standard practice – would normally have been responsible for completing any works left unfinished upon the master's death. It can be assumed, on the basis of their joint training and early collaboration, that Hubert and Jan van Eyck practised a nearly identical style of painting. Their associates, who operated in a still fundamentally collective workshop context, presumably were skilled in emulating their masters' style. It is out of the question that a commission on the scale of *The Ghent Altar* would have been completed without the involvement of the master's workshop; to gain an idea of numbers employed, it should be recalled that the Bruges councillors who visited Jan van Eyck's workshop in 1432 gave tips to twelve (!) assistants, or *cnapen*.

Would it be erroneous to think that, in the first instance, work on *The Ghent Altar* was continued first and foremost by members of Hubert's Ghent workshop, and that in the years immediately after 1426 Jan's advice was sought primarily on the design of those panels that were still incomplete? In view of his extensive travels, it is certainly possible that the Burgundian court artist would have intervened at occasional, brief points in time; nor is it inconceivable that Jan van Eyck's own assistants permanently reinforced Hubert's Ghent workshop until 1430, after which Jan was able to devote himself full-time to the altarpiece and ensure the stylistic homogeneity of its final appearance by spring 1432.

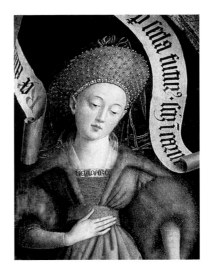

The Ghent Altarpiece, closed, 1432
Jan van Eyck and Workshop
The Cumaean Sibyl (detail)
Oil on panel, 204.8 x 33 cm
Ghent, St Bavo's Cathedral

ILLUSTRATION PAGE 28:
Jan and Hubert van Eyck and Workshop
The Ghent Altarpiece, closed, 1432
Oil on panel, 375 x 260 cm
Ghent, St Bavo's Cathedral

29

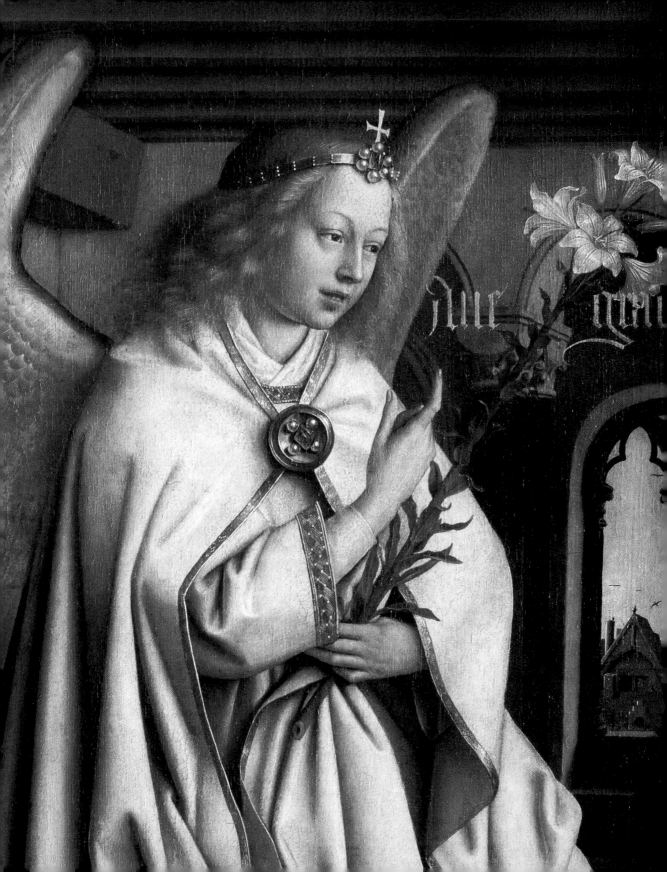

This hypothesis may explain the multilayered paint-structure of *The Ghent Altarpiece*, as established during the last thorough restoration of the altarpiece (1950–1951) – something that would appear to be rather unusually complex according to the latest examination of some of Jan van Eyck's other panels. The hypothesis may also explain the internal coherence of the overall composition and why its stylistic discrepancies are not limited to specific panels but are found across the polyptych's entirety. Thus the figures in *The Adoration of the Lamb* and in the lowest pictorial zone, for example, are somewhat more archaic in manner, suggesting the hand of Hubert, whereas the exotic vegetation found in the very same panels appears to require the botanical knowledge that Jan van Eyck could only have acquired in the course of his travels.

However, the issue of artistic authorship is not the only question hanging over *The Ghent Altarpiece*: details of its commission and the donor's reasons for financing such a remarkable foundation, of which the altarpiece is the most spectacular and public element, remain equally sketchy. As well as mentioning the masters involved, the quatrain on the frame – probably a reconstruction of the original inscription – identifies the donor of the altarpiece. By adding up the coloured letters in the fourth line as Roman numerals, by the way of a chronogram, the altarpiece's date of consecration and year of completion become evident: 6 May 1432. "P[ictor] HUBERTUS EEYCK. MAIOR QUO NEMO REPERTUS / INCEPIT. PONDUS. Q[ue] JOHANNES ARTE SECUN-DUS / [frater perfecit/perfunctus]. JUDOCI VYD PRECE FRETUS / **V**ERSU SEXTA **M**AI. **V**OS **C**OLLO**C**AT A**C**TA TUER**I**" (The painter Hubert van Eyck, one greater than whom is not to be found, began the work; Jan, his brother, second in the art, completed the difficult task at the request of Joos Vijd. The latter invites you with these verses to admire/protect the created work on 6 May [1432]).

The donor, Joos Vijd (†1439), came from a wealthy and influential family that had belonged to the Ghent patriciate for several generations. Around 1398 he married Elisabeth Borluut (†1443), the daughter of another patrician family; their marriage remained childless. Vijd, who also bore the title of Seigneur of Pamele and Ledeberge, ranked amongst the most senior and politically most in-fluential Ghent citizens of his day. As well as carrying out regular mandates for the city council, he was also warden (*kerkmeester*) of St John's Church in Ghent, and after the accession of Philip the Good (1419) became one of the Duke's trusted Ghent partisans. In 1425–1426 he participated in a mission to The Hague that successfully enforced the Burgundian claim to hegemony in Holland. Between 1410 and 1420 Vijd had paid for the construction of a bay in St John's Church and also financed a new chapel off the choir which still bears his name, and which was destined to serve as family chapel. Vijd, whose own house was beside the church, seems to have planned a major endowment right from the outset; hence the building works on the chapel over the crypt mark the earliest point at which he would have sought Hubert van Eyck's services, since it was for this new chapel, with its altar dedicated to All Saints, that the polyptych was destined.

The final phase of the endowment, which involved amongst other things the formal transfer of land owned by Vijd, was effected at a later date and was only officially chartered before the Ghent council on 13 May 1435. As well as furnish-ing the chapel with liturgical vestments and utensils early on and, of course, the altarpiece, Vijd also funded the appointment of two priests to hold a daily cele-bration of the Mass "to the glory of God, His Blessed Mother and all His saints". The Mass was to include prayers for the souls of the donor and his wife and ex-plicitly, too, for those of the forebears.

"Having read the entire literature on van Eyck – from Waagen to Beenken – only one thing about the Ghent Altar is sure, namely that its famous inscription has caused stylistic criticism greater embarrassments than this discipline – not exactly short on blunders – has ever known before."
MAX J. FRIEDLÄNDER, 1932

In commissioning an altarpiece so unparalleled in its proportions, Vijd was by no means concerned purely with securing his place in the hereafter, but also with boosting his prestige in the present. By adorning chapels with heraldic insignia, liturgical objects and altarpieces, donors – whether individuals or confraternities – could effectively publicise their elevated social status and/or their social ambitions. Both in its impressive format and its no less ambitious representations, *The Ghent Altarpiece* demonstrates the donor's paramount desire to show off and their determination to outstrip by far all other endowments to St John's, if not to each and every other church and monastery in Ghent.

In the case of the present altarpiece, the question inevitably arises as to which earlier works both donor and artist were actually seeking to outdo. Composed of two physically distinct horizontal registers, the *Ghent Altar* is namely comparable in its shape and structure with no other work of Franco-Flemish art; even the large, folding German altarpieces from the period around 1400 differ fundamentally in conception: the twelve individual panels of the two registers of *The Ghent Altarpiece* are not of identical size, whereby its structure appears somewhat arbitrary. In fact, however, this structure is linked with the stability of the altarpiece. The dimensions of the Vijd chapel did not allow the polyptych to be opened out in full; the interior could only be presented with angled wings. Due to the different widths of the panels above and below, the lower register supported the upper and thereby prevented the folding altar from collapsing.

Perhaps the altarpiece deliberately negated the actual size of the chapel, so that the representations in its opened position would recall a transcendent chapel wall, upon which the viewer was offered an apocalyptic vision of Paradise on the Day of Judgement. This vision was all the more luminous and magnificent simply because it was exquisitely painted on panel, and not on the actual wall. This may shed some light on the perceived nature of the artistic competition: perhaps it was a question of excelling not simply earlier altarpieces, but first and foremost the monumental murals that in those days commonly decorated both churches and secular palaces.

The Ghent Altarpiece clearly was intended to earn for its donors a very public prestige, both from an artistic and a social point of view. Amongst the ruling Burgundians, St John's Church was the preferred location within Ghent for official ceremonies and the bestowing of ducal favours. It should also be noted that Vijd entrusted the completion of the work to none other than Jan van Eyck. As valet de chambre to Philip the Good, the painter – who could not possibly have accepted the commission without the Duke's express permission – naturally commanded a particularly high regard, which also reflected onto the donor. By choosing Jan van Eyck, Vijd was able not only to ensure the continuity of the unfinished composition but also to count on the curiosity of the court. That such considerations played an important role is evidenced by the date of consecration given in the quatrain.

On 6 May 1432, St John's church not only witnessed the consecration of the altarpiece, but was also the site of an event that was of the highest significance for the Burgundian dynasty: the baptism of a son of Philip the Good and Isabella of Portugal, upon whom the hopes of the continuation of the dynasty were pinned. Celebrated on the feast of the martyrdom of St John the Evangelist, in the presence of a large public, the ceremony was attended by members of the Burgundian-Flemish nobility, church dignitaries, diplomats, civic deputies, representatives of the County of Flanders and Ghent's most senior patriciate. The numerous guests from near and far also included Joos Vijd and Jan van Eyck.

"Of the lower panels of the Ghent Altarpiece, however, two are devoted exclusively to the almost life-sized kneeling figures of the donor Jodocus Vydt and his wife Elisabeth Burluut; and here, perhaps for the first time, the modern portrait comes directly to meet us against the neutral ground of a stone-coloured niche. It is one of those instances in art history when an invention approaches supreme perfection at its very first attempt."
JACOB BURCKHARD, 1885

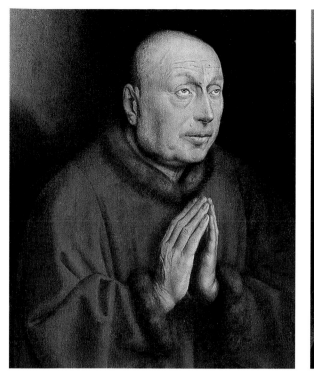
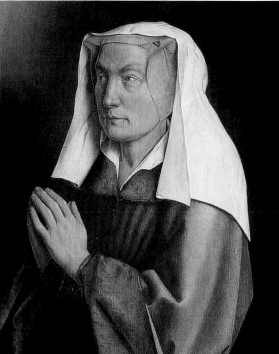

The infant, who – although nobody could foresee it then – died over a few weeks, was held over the baptismal font by his four noble godparents and named Joos (Josse).

As the chronicler Monstrelet noted with astonishment, the choice of name did not follow the Burgundian convention of christening a child after one of its four godparents, but was based on a vow made earlier by Isabella to call her son after Saint Jodocus. Although a namesake, Joos Vijd was therefore not one of the godparents to the young scion of Burgundy, but might have taken the choice of name as a particular sign of the Duke's goodwill towards him. His plans for the installation and consecration of *The Ghent Altarpiece* were presumably influenced in a very concrete manner by the child's birth and baptism, for the large numbers of dignitaries and guests who would be attending the church ceremony obviously guaranteed Vijd a particularly sophisticated audience for his ambitious altarpiece. The sight of *The Ghent Altarpiece* will undoubtedly have numbered amongst the highpoints of the Burgundian christening.

By the time he had finished *The Ghent Altarpiece*, at the very latest, Jan van Eyck had become an artist famed far beyond the bounds of the Netherlands, his name praised even in Italian writings on art of the day. During or just after finishing the altarpiece, Jan van Eyck moved to Bruges, the financial and economic capital of Flanders. The fame that *The Ghent Altar* had earned him amongst his contemporaries would from now on bring him commissions for altarpieces, devotional panels and portraits from wealthy patrons at home and abroad.

The Ghent Altarpiece, closed, 1432
Jan and Hubert van Eyck and Workshop
The Donor Joos Vijd (detail)
Oil on panel, 145.7 x 51 cm
Jan and Hubert van Eyck and Workshop
The Donor's Wife Elisabeth Borluut (detail)
Oil on panel, 145.8 x 50.7 cm
Ghent, St Bavo's Cathedral

The life-sized portraits of donor *Joos Vijd* and his wife *Elisabeth Borluut* are no idealized representations, but exude their realism even today. The childless couple were part of Ghent's influential and aristocratic patriciate, and the monumental *Ghent Altarpiece* was intended not least to demonstrate their social prestige.

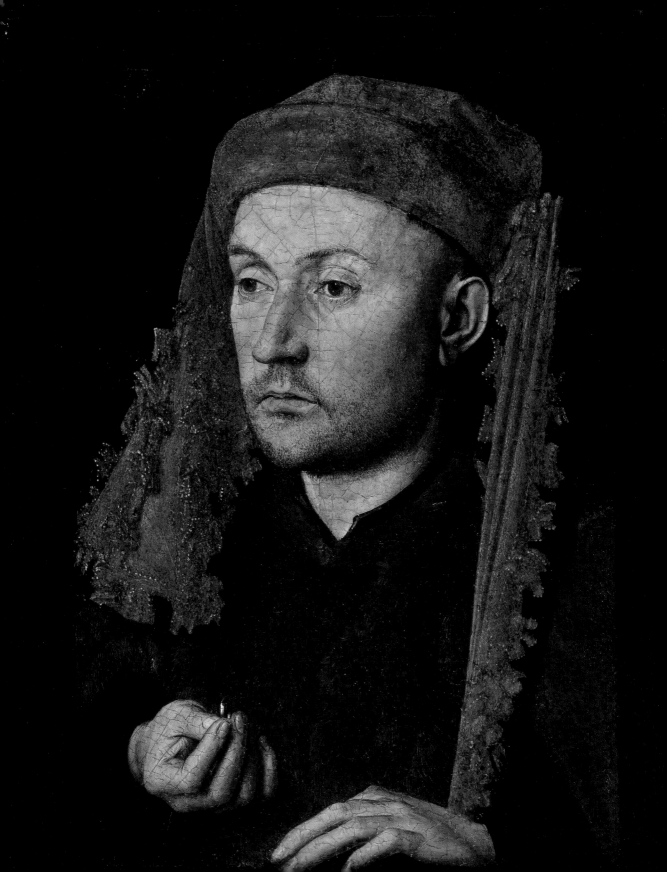

Portraits

Portraits occupy an important position in Jan van Eyck's œuvre. In addition to representations of donors, he painted apparently "autonomous" portraits that were displayed in private homes as memorials or as part of ancestral galleries and therefore escaped the attention of iconoclasts and looters. Jan van Eyck was one of the first artists to paint such likenesses; he even transformed the Byzantine icon of Christ into a portrait (pp. 46, 47). The emergence of portraiture as an autonomous pictorial genre was caused by a growing consciousness of individual identity after 1400. Portraiture had previously been bound up with the notion that a painted likeness was a privilege reserved for rulers; even in the late 14th century, portraits always represented princes. Over the 15th century, however, the demand for individual portraits spread to every social elite. A driving force behind this development was the desire by urban patricians, some of them with substantial financial resources, to emulate the lifestyle of nobility.

As court painter, Jan van Eyck faced a constant demand for portraits, including pictures of family ancestors and portraits to be sent to royal courts or presented to loyal retainers. Constants in Jan van Eyck's early portraiture are frames, inscriptions and illusionism, coupled with fastidious powers of observation with regard to the sitter's physical appearance. They are, however, also found amongst contemporary Netherlandish painters and were subsequently spread by Petrus Christus and Hans Memling.

The earliest surviving portrait by van Eyck, the *Portrait of a Man with a Blue Chaperon* (p. 34), exemplifies the illusionistic nature of the likeness. It shows a man wearing a blue headdress against a neutral dark background. The face is lit from the left to enhance the contrasts of light and shadow. The stubble of the beard is painted with painstaking precision; nothing is idealized. The man's left hand appears to be resting on a parapet that originally coincided with the painted frame. In his right hand he holds up a ring, which projects out of the panel into the world of the viewer. The work was earlier thought to be the portrait of a goldsmith, but is today assumed to represent a type of painting circulated to propose a marriage. The turban-like chaperon, which went out of fashion at the beginning of the 1430s, and the distinguished style of dress identify the unknown sitter as a Burgundian-Netherlandish nobleman.

The *Portrait of a Man (Léal Souvenir)* (p. 38) served a quite different function. It is the first signed and dated work by Jan van Eyck after *The Ghent Altarpiece*. It

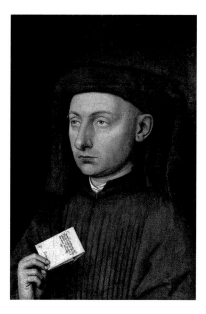

Follower of Jan van Eyck
Portrait of Marco Barbarigo, c. 1450
Oil on panel, 24.1 x 15.9 cm
London, The National Gallery

ILLUSTRATION PAGE 34:
Portrait of a Man with a Blue Chaperon, c. 1430
Oil on panel, 22.5 x 16.6 cm
Bucharest, Muzeul National de Arta al României

Portrait of Margarete van Eyck, 1439
Oil on panel, 32.5 x 26 cm
Bruges, Groeningemuseum

In the 18th century this portrait of Jan van Eyck's wife hung in the chapel of the Bruges guild of painters. It was secured with heavy chains since its pendant, a self-portrait of the artist, had earlier been stolen. This pendant was probably not the *Man in a Turban* (p. 37), which is also considered a self-portrait by van Eyck.

ILLUSTRATION PAGE 37:
A Man in a Turban (Self-portrait?), 1433
Oil on panel, 33.3 x 25.8 cm (with frame)
London, The National Gallery

shows a man wearing a green chaperon and dressed in a red jacket trimmed with brown fur. In his right hand he holds a furled sheet of manuscript. His left arm is hidden behind a cracked parapet that is painted to imitate stone. As though carved into the parapet are the words LEAL SOVVENIR, and above them, in Greek letters, TYM.WØEOC (tym.otheos). Another inscription along the bottom of the parapet reads: "Actu[m] an[n]o d[omi]ni. 1432. 10. die octobris. a. ioh[anne] de Eyck" (Done in the year of Our Lord 1432 on the 10th day of October by Jan van Eyck). This signature is unusual in Jan van Eyck's œuvre but is documented to have been employed by an artist in his immediate sphere that very same year: the lost *Portrait of Jacoba of Bavaria* (p. 11) by Lambert van Eyck apparently also included the phrase "actum anno domini 1432".

The identity of the sitter, whose likeness is described as a "faithful souvenir" and authenticated by an inscription that resembles a notarial deed, is once again unknown. Perhaps he was a learned lawyer, or perhaps the portrait simply refers to some legal act; the document pointedly included in the picture may allude to this. It is possible that the portrait served a commemorative purpose, although whether it was painted as an epitaph, and thus after the sitter's death, is unclear.

The *Man in a Turban* (p. 37) is one of the masterpieces within van Eyck's œuvre and represents a milestone in portraiture. It owes its extraordinary impact to the emphasized contrast between the face, lit from the left, the elaborately wound chaperon and the dark background; even hands are omitted from the representation. The compositional device whereby the sitter's eyes "gaze out of the picture" finds its first use in an autonomous portrait and seems to imply an intimacy between viewer and subject. For this reason the panel has often been considered a self-portrait. A lost self-portrait of the artist, painted as a pendant to the portrait of his wife *Margarete van Eyck* (p. 36), is indeed documented in records prior to 1769. The interpretation as self-portrait is supported by the painted inscription at the bottom of the frame, which provides no information about the identity of the sitter, but simply states: "Joh[ann]es de eyck me fecit an[n]o mcccc 33 21 octobris" (Jan van Eyck made me 1433 21 October). Above this signature line, along the top of the frame, we encounter the personal motto of the artist – "ALC IXH XAN". This phrase, which literally means "as I can", appears on several of Jan van Eyck's portraits and small-format paintings and can be interpreted as a token of modesty in the sense of "as good as I am capable of". The word "I", written partly in Greek lettering, is simultaneously a play upon the IXH monogram of Christ and thereby may allude to a personal form of the *imitatio Christi*. Although there is much in favour of a self-portrait, this idea remains just a theory. All that is certain is that the portrait possesses a more intimate character than, for example, the *Léal Souvenir* portrait (p. 38) and therefore was probably made for a private context.

The *Portrait of Baudouin de Lannoy* (p. 39), on the other hand, can be assumed to have fulfilled an official function: the Governor of Lille is shown not only with the insignia of the Order of the Golden Fleece and a military staff, but also dressed in the brocade cloak and large fur hat worn on ceremonial occasions. Nothing seems to have been embellished – we have moved far away from the idealizing court portraits of the early 15th century. In the 16th century this little portrait was recorded in a collection of portrait drawings, the so-called Receuil d'Arras; since the sitters' name was then recorded it is possible to identify the Hainault nobleman for sure.

From a formal point of view, the portrait of the Bruges goldsmith *Jan de Leeuw* (p. 40) is closely related to *A Man in a Turban*. Its intimacy suggests that

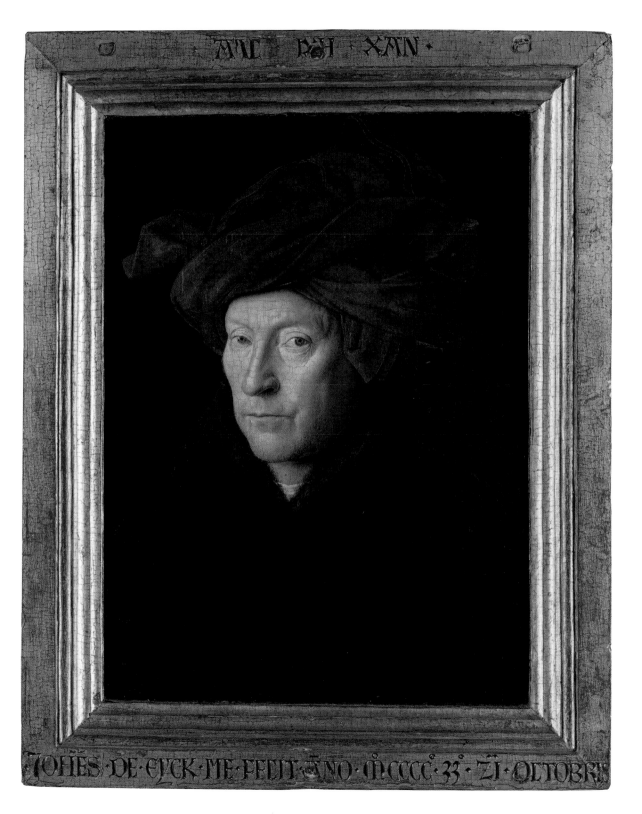

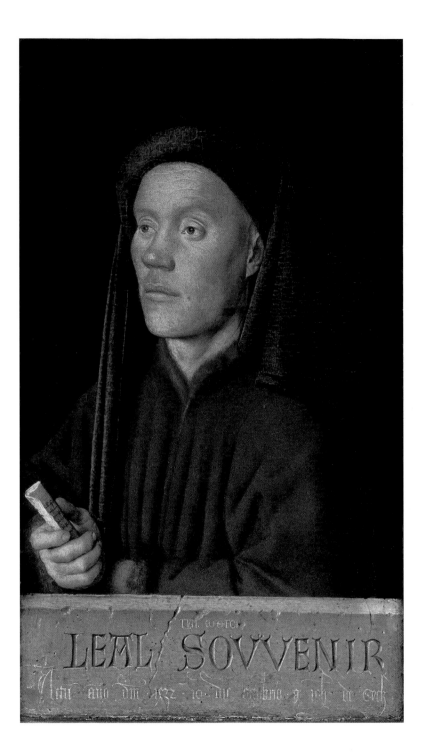

Portrait of a Man (Léal Souvenir), 1432
Oil on panel, 33.3 x 18.9 cm
London, The National Gallery

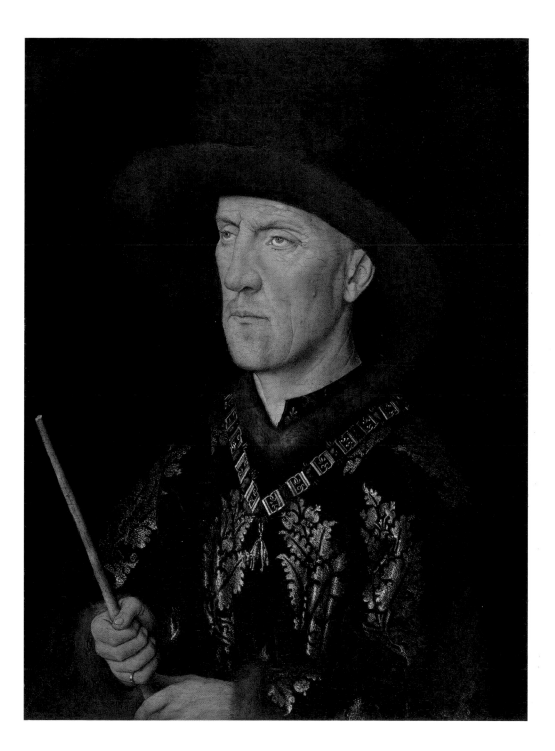

Portrait of Baudouin de Lannoy, c. 1435
Oil on panel, 26 x 19.5 cm
Berlin, Staatliche Museen zu Berlin, Gemäldegalerie

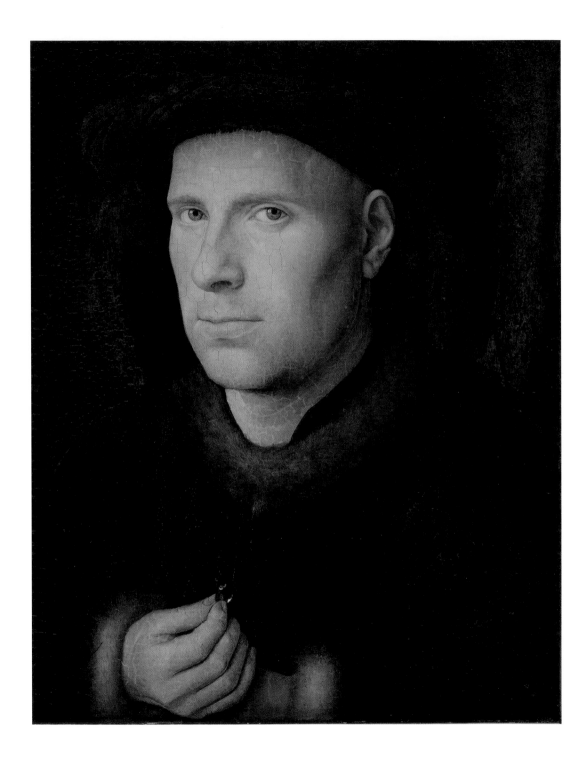

***Portrait of Jan de Leeuw**, 1436*
Oil on panel, 24.5 x 19 cm
Vienna, Kunsthistorisches Museum, Gemäldegalerie

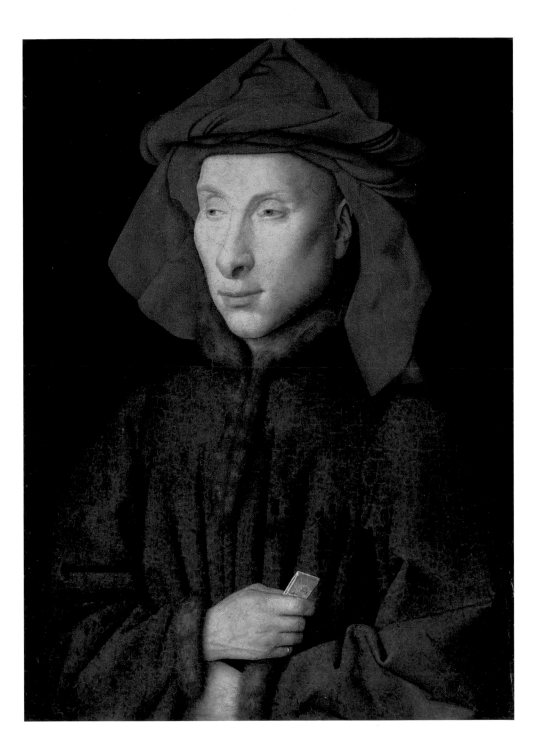

Portrait of Giovanni di Nicolao Arnolfini, c. 1438
Oil on panel, 29 x 20 cm
Berlin, Staatliche Museen zu Berlin, Gemäldegalerie

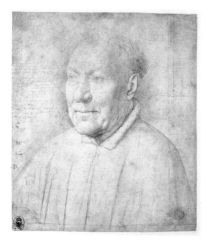

Portrait Drawing of Niccolò Albergati, 1435
Silverpoint on paper prepared with white chalk,
21.4 x 18 cm
Dresden, Staatliche Kunstsammlungen Dresden,
Kupferstich-Kabinett

Jan van Eyck sketched this *Portrait Drawing of
Niccolò Albergati* from life during the peace con-
gress of Arras in 1435. He made notes on colours
on the same sheet. Three years later, using his
drawing and notes as a guide, van Eyck executed
the Cardinal's portrait in oils, using a mechan-
ical means of scale enlargement to transfer the
drawing onto the ground of the panel.

artist and sitter moved in the same circles and knew each other well. Jan de Leeuw
wears a black jacket trimmed with fur and a black chaperon. The distribution
of light and shade across his face is rendered with analytical precision. The gold-
smith's gaze is turned upon the viewer; in his right hand, he holds up a ring set
with a precious stone as a symbol of his profession. The gesture may well convey
an ambivalent meaning, since the motif of the ring was also a conventional
element of engagement portraits. Once again van Eyck exploits the suggestive
power of his illusionism, leaving the left arm to rest behind the frame while the
right seems to protrude out of the pictorial plane. Since the painting still boasts
its original double frame, this effect can be clearly appreciated. The inner frame
is moulded and is set off strongly against the portrait by its pale colour. The
outer frame is painted to look like bronze and appears smooth. Around its edge
runs a Flemish inscription: "Jan de [Leeuw], who first opened his eyes on the
Feast of St Ursula [21 October], 1401. Now Jan van Eyck has painted me, you can
see when he began it. 1436." A golden lion replaces, by way of a pictogram, the
surname de Leeuw and also alludes to the sitter's profession. Upon examining
the inscription more closely, it emerges that some of the letters appear to be
carved into the frame while others stand out in relief. Here lies the solution to
the riddle in the inscription: a double chronogram that, when the letters in relief
are added together, once again gives the years 1401 and 1436. The sitter's age can
thus be calculated as 35 years old. The inscription is also interesting from another
point of view, namely, it appears to be speaking: the portrait addresses the viewer
in the first person singular. The dialogue with the viewer initiated by the challen-
ging gaze of the sitter is continued in the "spoken" address on the frame.

This phenomenon reappears in the portrait of *Margarete van Eyck* (p. 36) of
1439, van Eyck's only extant portrait of a female sitter. Here, too, the eyes gazing
out of the picture are combined with a "talking inscription" and a dialogue is
thereby established with the viewer. The portrait is undoubtedly the artist's most
personal work. His wife is dressed in the fashion of polite society, in a red coat
trimmed with fur and with the horned hairstyle and white scarf of married
women. Why the portrait was painted and where it was destined to hang is un-
known. Although the inscription is composed in Latin, the portrait was probably
made on a personal occasion, perhaps to accompany a self-portrait of the artist.
Both works, this portrait of *Margarete van Eyck* and a lost self-portrait, later
hung in the chapel of the Bruges painters.

There was certainly no official reason for van Eyck to immortalise his wife in
a painting. His other portraits were paid commissions, some of them executed
in his capacity as court painter. One such is his portrait of Cardinal *Niccolò
Albergati* (p. 43), which differs formally from the other portraits discussed up till
now in its renunciation of illusionistic elements, and which may represent a spe-
cific type of court portrait. It shows the elderly cleric in his cardinal's robes, lined
and trimmed with white fur, against a neutral background. The wrinkles on his
face, the stubble of his beard and the hair growing back beneath his tonsure are
rendered with extreme precision. With its deliberate omission of the hands, the
portrait gains in focus and conveys an unusual sense of dignity.

A reliable 17th century source, which reproduces the information provided
by the inscription on the lost original frame, testifies to the sitter's identity: "A
true likeness by Jan van Eyck dated 1438, showing the Cardinal of Santa Croce,
who had been sent to Bruges by the Pope at that time to make peace between
Duke Philip [of Burgundy] and the Dauphin of France over his [Philip's] father's
death)." Niccolò Albergati, Cardinal of the titular church of Santa Croce in

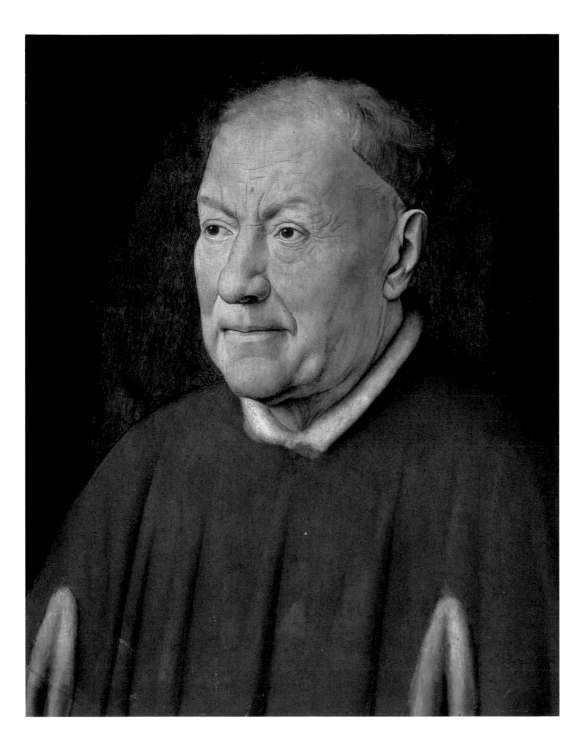

Portrait of Niccolò Albergati, 1438
Oil on panel, 34.1 x 27.3 cm
Vienna, Kunsthistorisches Museum, Gemäldegalerie

Gerusalemme in Rome, participated as papal legate in the peace congress held at Arras in 1435. The aim of the congress was to effect a reconciliation between Philip the Good and the French Dauphin Charles (VII) in the wake of the 1419 assassination of Philip's father, John the Fearless.

Philip summoned his court painter to Arras while negotiations were still in progress, and van Eyck executed a drawing of his model from life that would serve as the preliminary study for the painting three years later. The sketch (p. 42), in silverpoint on prepared paper, is the only surviving drawing from van Eyck's hand and offers unique insights into his working process. He used his styli to document and correct – with painstaking precision – the outlines of the face, eyes, nose and mouth before modelling their volumes with hatching. He also made careful notes in his native Mosan dialect in the sheet margins, supplementing his monochrome sketch with details of the nuances of colour seen in the Cardinal's face and eyes. The drawing and these notes subsequently formed the basis for the painting, executed some time later in 1438. The portrait drawing was first transferred onto the ground of the panel with the aid of a mechanical means of scale enlargement, as marks on the sheet reveal. The actual painting was probably carried out by Jan van Eyck with participation of his assistants.

Van Eyck's most important contribution to the field of portraiture is a painting as unique as it is enigmatic: *The Arnolfini Marriage* (p. 45), whose bold compositional strategy would not be taken up again until Velázquez' *Las Meninas* (1656). The double portrait, one of the most famous paintings in the history of

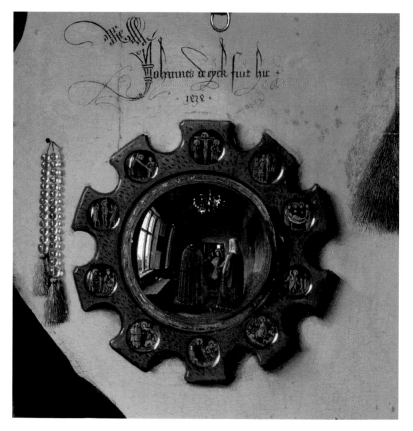

ILLUSTRATIONS PAGES 44 AND 45:
The Arnolfini Marriage, 1434
Oil on panel, 81.8 x 59.7 cm
London, The National Gallery

The convex mirror in the background of this double portrait is one of the most fascinating details in the painter's œuvre. It shows not only the couple in rear view, but in the doorway a tiny self-portrait of van Eyck himself, entering the room with a companion and thus becoming a witness to the scene.

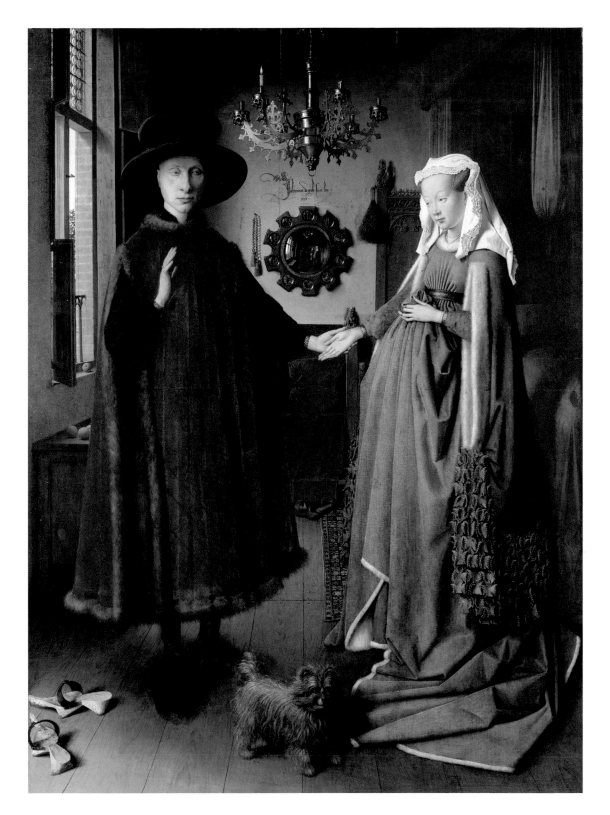

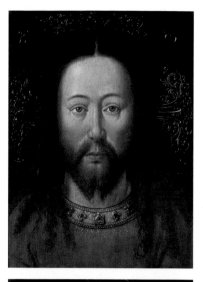

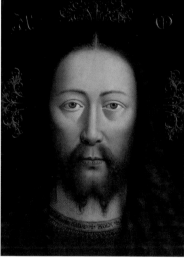

ILLUSTRATION ABOVE:
Jan van Eyck (17th century copy)
Vera Icon (The Face of Christ), 1440
Oil on panel, 33.4 x 26.8 cm
Bruges, Groeningemuseum

ILLUSTRATION BELOW:
Jan van Eyck (copy)
Vera Icon (The Face of Christ), 1439
Oil on panel, 50 x 37 cm
Munich, Bayerische Staatsgemäldesammlungen,
Alte Pinakothek

ILLUSTRATION PAGE 47:
Jan van Eyck (copy)
Vera Icon (The Face of Christ), 1438
Oil on panel, 44 x 32 cm
Berlin, Staatliche Museen zu Berlin –
Preußischer Kulturbesitz, Gemäldegalerie

art, offers a detailed view of the interior of a seemingly ordinary bedchamber. Husband and wife stand side by side, the husband holding his wife's right hand in his left; both are sumptuously dressed and shown in full length. In front of the couple is a dog, and clearly visible on the right behind the woman is a made-up bed. On the left, daylight falls through an open window into the back half of the room – a bold device that later would also be taken up by Petrus Christus and that immediately recalls paintings by Vermeer. Above a bench against the far wall is a magnificent convex mirror framed by scenes from Christ's Passion, with a rosary hanging to its left. Painted in Burgundian Chancery script on the wall above the mirror is the signature of the artist: "Johannes de Eyck fuit hic. 1434" (p. 44). The central vertical axis described by the dog, hands, mirror and signature terminates at the ceiling in the chandelier with one candle burning in it. Van Eyck here anticipates three future genres of painting – the full-length portrait, the interior and the still life. The most spectacular element of the composition, however, is the convex mirror: within its reflection, van Eyck shows us not only the couple and the room around them in rear view, but also – as closer examination reveals – two more figures standing in a doorway in front of the couple. The mirror thereby expands the pictorial space beyond the bounds of the actual painting into the world occupied by the viewer, represented here by the artist and a companion.

On the basis of an inventory entry, it has been possible to link the painting with the Arnolfini family of bankers from Lucca. The Arnolfini maintained close business links with Flanders and several members of the family had settled there. Amongst them was Giovanni di Arrigo Arnolfini, who was married to Giovanna Cenami and lived in Jan van Eyck's neighbourhood in Bruges, and who, as a financier, was also respected in court circles. For a long time, *The Arnolfini Marriage* was firmly believed to be a painted marriage certificate showing Giovanni di Arrigo Arnolfini giving his hand in marriage to his wife Giovanna Cenami.

Only the discovery that Jan van Eyck's subject is in fact Giovanni di Nicolao Arnolfini, and not his better-known brother Giovanni di Arrigo, who did not get married until 1447, has made it possible to re-evaluate the painting, which is now considered to have a memorial function. In 1426 Giovanni di Nicolao married Costanza Trenta, who was related to the Medici by marriage. Costanza died in 1433, and it is possible that the painting was commissioned to mark the first anniversary of her death. In addition to the date given in the signature, other motifs within the painting fit a commemorative context: the candle burning in the widower's half of the painting can thus be interpreted as the light of life, contrasting with the extinguished life on the side of his deceased wife. The inclusion of the dog as a symbol of fidelity is possibly a reference to carvings on Late Mediaeval tombs, where it is a familiar motif. In the context of a memorial painting, the scenes of the Passion and Resurrection which frame the mirror naturally stand for the promise of eternal life proceeding out of Christ's death on the Cross. Although primarily a secular subject, *The Arnolfini Marriage* is without doubt closely related to van Eyck's Madonna paintings, not only at the formal level of figural style, perspective and composition, but also in terms of its symbolically charged pictorial language and its intellectual conception.

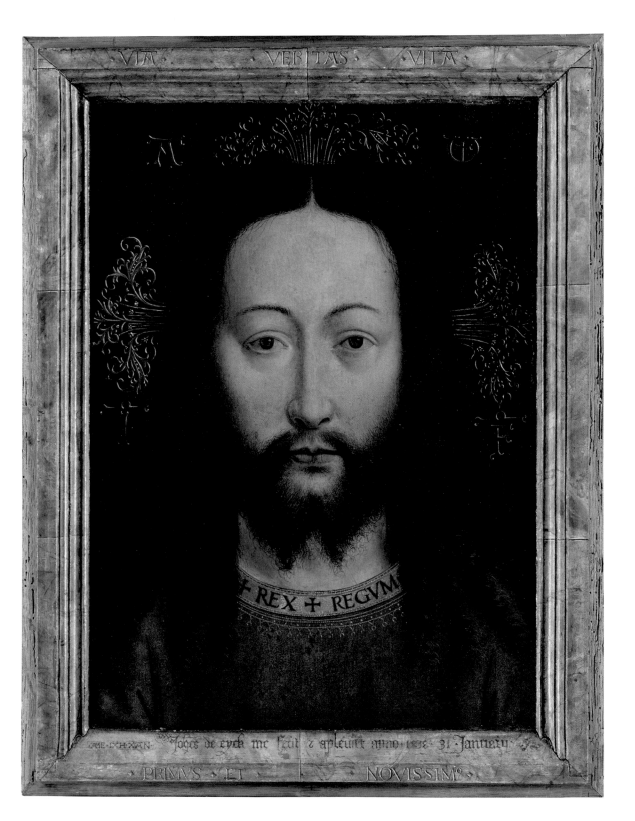

47

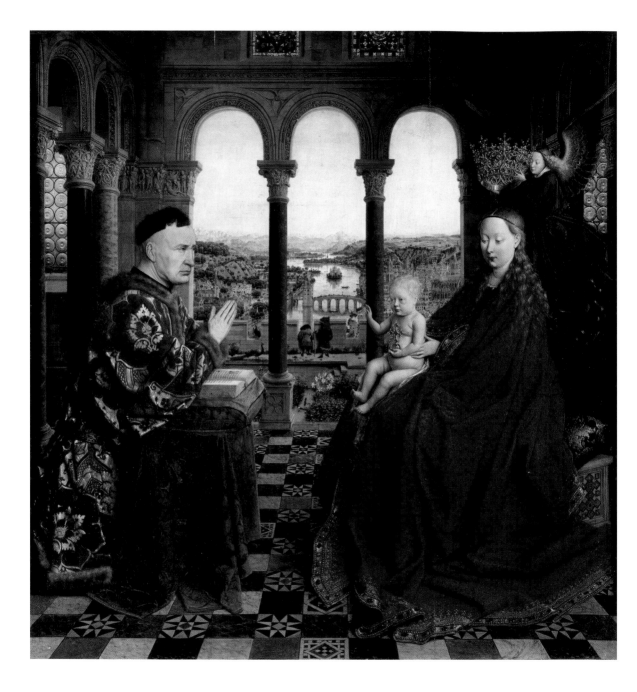

Altarpieces and Devotional Paintings

Jan van Eyck's surviving religious works include almost no representations of the Passion or Christian saints; his œuvre is dominated by paintings of the Madonna. *The Ghent Altarpiece* of 1432 (chap. 2) was followed by the *Madonna of Joris van der Paele* (1436, pp. 54–55) the Dresden *Triptych of the Virgin and Child* (1437, pp. 56–58) and the *Madonna at the Fountain* (1439, p. 67). The Washington *Annunciation* (p. 51 right) was probably made only shortly after *The Ghent Altarpiece*, as evinced by stylistic parallels between the figures in *The Annunciation* and the choirs of angels in Ghent, above all in the handling of the brocades. *The Annunciation* is presumably the sole surviving painting by Jan van Eyck to have been executed for Philip the Good, and was most likely destined for the Chartreuse de Champmol, a Carthusian monastery founded by Philip's grandfather, the first Duke of Burgundy. An Annunciation panel known to have been in the charterhouse chapel as late as 1791 – just after the French Revolution – is likely to be the same painting. In the early 19th century, however, all trace of the panel in Dijon vanishes. The Champmol charterhouse, which was situated close to the Burgundian capital, served as a dynastic necropolis and played a prominent part in the self-representation of the ducal family. *The Annunciation* was originally the left wing of a lost triptych, whose overall subject and composition are today unknown. The recent restoration of *The Annunciation*, which was transferred from panel to canvas during the 19th century, has brought to light the sophistication of its painting and dispelled any doubts as to van Eyck's authorship.

The painter and his contemporaries understood that the Annunciation described in St Luke's Gospel (Luke 1:26–38) was of fundamental importance, since it marked the beginning of the incarnation of Christ, whose death and Resurrection promised redemption for humankind. At the same time, it marked the transition from the Old to the New Testament, from the epoch under the law – *sub lege* – to the epoch under grace – *sub gratia*.

Several details in the Washington *Annunciation* make reference to this transition. Thus the fictitious church interior, compiled from existing sacred architecture, can be read in allegorical terms: the stylistic contrast between the rounded Romanesque windows of the clerestory and the pointed Gothic arcades lower down symbolises the shift from the Mosaic synagogue to the Christian church. The three clear-glass windows behind the Virgin's head refer to her chastity and at the same time allude to the Trinity. They thereby contrast with the Old Testa-

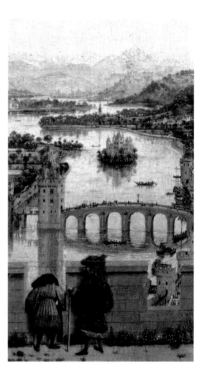

ILLUSTRATIONS PAGES 48 AND 49:
Madonna of Chancellor Nicolas Rolin, c. 1435
Oil on panel, 65 x 62.3 cm
Paris, Musée du Louvre

As Chancellor of Burgundy, Nicolas Rolin was one of the most powerful figures at court. The feared diplomat was one of the most important art patrons of his day. In addition to the altarpiece that he commissioned from Jan van Eyck for his family chapel in Autun, he also endowed a hospital in Beaune, whose *Last Judgement* altarpiece was painted by Rogier van der Weyden.

ment God appearing in the stained-glass clerestory window high above, once again emphasizing the passage from the Old to the New Covenant.

The stained glass is also related to the wall paintings that can be seen to the left and right of the clerestory window, in which banderoles and inscriptions accompany scenes from the life of Moses: on the left, the finding of Moses by Pharaoh's daughter (Exod. 2:6), and on the right Moses receiving the Ten Commandments (Exod. 20). The finding of Moses was considered to prefigure the incarnation of Christ, while the institution of the Old Covenant through the delivery of the Ten Commandments was simultaneously interpreted as prophesying the New Covenant that commenced with the Annunciation. Van Eyck executes these elements of his composition in a deliberately anachronistic style that resembles the art of the High Gothic. This old-fashioned style relegates the Old Testament to the past, but also testifies to van Eyck's antiquarian interest in the art of earlier centuries.

Beneath the triforium there are two wall medallions depicting Isaac and Jacob. These, too, possess a typological significance: Isaac's blessing of his son Jacob (Gen. 27:23) was seen as a prefiguration of the Annunciation. The motifs appearing in the upper half of the composition refer to the Old Covenant and the Christian concept of the Trinity. Scenes from the Old Testament are also found in the tiles on the floor, framed within ornamental borders containing the signs of the zodiac. They include episodes from the story of Samson (Judges 15–16) that look forward to the sacrifice of Christ, and in the central foreground David slaying Goliath (I Samuel 17), a victory that was typologically linked with Christ's victory over Satan and death.

Both aspects – the death and Resurrection of Christ and the replacement of the Old Testament by the New – are equally present in van Eyck's *Annunciation* and come together, both formally and theologically, in the figure of the Virgin. The fact that van Eyck's *Annunciation* contains so many layers of meaning is not in itself surprising, since typological associations of this kind were a common feature of the biblical exegesis and sermons of the day; what is impressive, rather, is the way in which they are incorporated seemingly incidentally into the composition and in a subtle, logical and spatially concentrated manner. It is important to remember that *The Annunciation* is only a fragment of a triptych and that its full significance cannot ultimately be explained.

Probably not much later, around 1435, van Eyck finished the *Madonna of Chancellor Nicolas Rolin* (p. 48). This painting, too, reveals close similarities in technique with some of the panels making up *The Ghent Altar*, but also resembles the *Madonna of Joris van der Paele,* dated 1436 (pp. 54–55). The almost symmetrical composition shows the donor kneeling in prayer before the enthroned Virgin and Child. The Chancellor, seen virtually in profile, is wearing a brocade coat trimmed with fur; a book of hours lies open in front of him on a prayer-desk draped with a velvet cloth. The Virgin, seated on a cushioned bench, is swathed in a red robe whose hem is trimmed with precious stones and pearls and bordered by lettering stitched in gold thread, which spells out excerpts from Matins in the Little Office of Our Lady. An angel holds the crown of the Queen of Heaven over the Virgin's head. On her lap sits the naked Infant Christ, holding a crystal orb in his left hand and with his right hand raised in blessing. Since both these motifs are associated with Christ as *Salvator Mundi,* the Saviour of the World, they call to mind Jesus's death and Resurrection. A similar symbolism is found in the four figural reliefs on the capitals behind the heads of the Chancellor and the Virgin, showing the Expulsion from Paradise, the Sacrifice of Cain and his subsequent murder of Abel, and the meeting of Abraham and Melchizedek. In illustrating

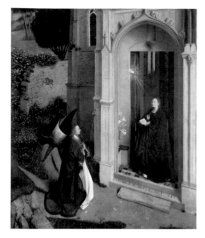

Petrus Christus (?)
The Annunciation, c. 1445
Oil on panel, 77.5 x 64.1 cm
New York, The Metropolitan Museum of Art.
The Friedsam Collection, Bequest of Michael
Friedsam, 1931 (32.100.35)

ILLUSTRATION RIGHT:
The Annunciation, c. 1433
Oil on canvas (transferred from panel),
92.7 x 36.7 cm
Washington, DC, National Gallery of Art.
Andrew W. Mellon Collection

The Annunciation is one of the central events
in Christianity. It marks the end of the Old
Covenant and at the same time inaugurates
God's New Covenant with humankind, based
on divine grace. Van Eyck illustrates this new
era with the more modern Gothic architecture,
while associating the formal vocabulary of the
Romanesque with the Old Testament. Petrus
Christus drew inspiration from van Eyck's
portrayal of the Archangel Gabriel in his own
painting of the same scene (see above).

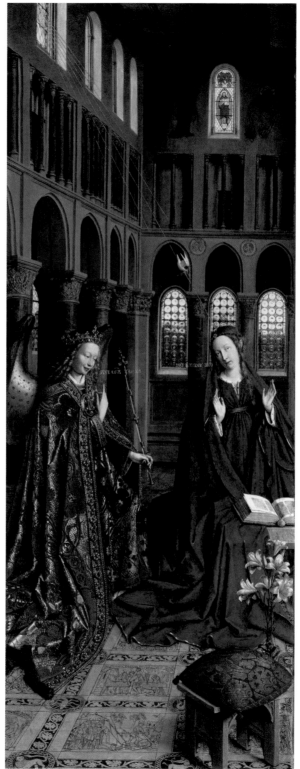

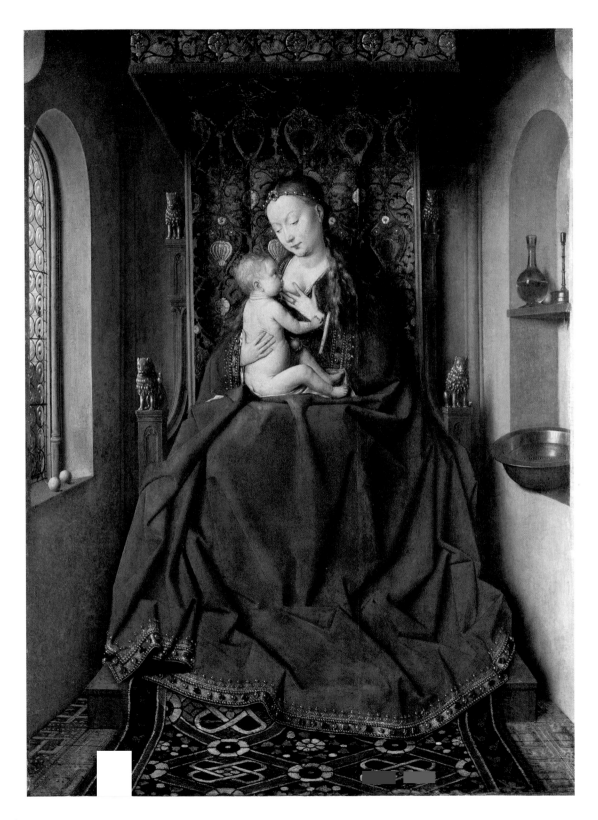

sin, sacrifice and forgiveness, they refer typologically to the promise of redemption embodied by Christ.

Van Eyck locates the scene within a sacred interior whose perspective depth is defined by floor tiles apparently converging upon a single vanishing point. The most striking architectural feature is a three-partite arcade, which can be read as a sign of sovereignty and which refers to the heavenly realm in the background. Just beyond the arcade lies an enclosed paradise garden containing magpies, peacocks and also two men, who serve to direct our gaze out towards the landscape beyond. The detailed background landscape of the *Rolin Madonna*, which is seen from two viewpoints, undoubtedly ranks amongst the most impressive examples of Early Netherlandish landscape painting (p. 49). Both for this reason and in terms of its place in the evolution of the donor portrait, the panel occupies a prominent position in van Eyck's œuvre.

Nicolas Rolin (1376–1462), the donor, came from Autun. The lawyer had already served John the Fearless and, following the duke's assassination (1419), became a trusted advisor to Philip the Good. In 1422 Philip appointed him Chancellor of Burgundy and elevated him to the nobility. Rolin rose to become one of the wealthiest men at the Burgundian court and numbered amongst the most important charitable patrons of his day.

Jan van Eyck's painting seems to be infused with Rolin's authority. It seems almost presumptuos that the donor should enjoy the privilege of a personal audience with the Virgin and Child. Joos Vijd, as the donor of *The Ghent Altarpiece*, may have had himself portrayed in life size, but he was nevertheless content to appear in a modest niche on the hierarchically less important, everyday side of the retable. Here, on the other hand, Rolin not only takes the same physical scale as the Mother of God, but also insists on her immediate presence; he does not even require the particular commendation of an intermediating saint. Such thoughts arise out of a fundamental misunderstanding of what is being portrayed – a misunderstanding wrought by van Eyck's mimetic realism. For the artist is representing not the meeting between the donor and the object of his devotions, but rather a spiritual vision of the Blessed Virgin evoked by pious prayers and meditation, as familiar from dedication miniatures.

The Virgin and the Infant Christ conferring his blessing no more appear in reality before the donor's eyes than the sacred interior, the paradise garden, or the universal landscape. Everything that Jan van Eyck has depicted here with apparent verisimilitude is in truth only visible to the donor's inner eye. Hence the *Rolin Madonna* can be interpreted as a painted prayer or viewed as a portrait of the Chancellor's devotions.

It is likely that the original frame – now lost – bore inscriptions that clarified the explicit devotional context for which the painting was intended. It was originally destined for Rolin's family chapel in Notre-Dame-du-Châtel in Autun, to which the Chancellor had made a first endowment in 1429–1430, and for which in 1432 he even obtained a papal bull that granted indulgences to any benefactors of the chapel. A second endowment followed in 1436, presumably marking the installation of the *Rolin Madonna*. It is likely that van Eyck's painting served not just as an altarpiece but also as a means of insuring the *memoria* of Rolin, his privileges and charitable donations. The *Rolin Madonna* is the first surviving painting in which van Eyck employs the motif of the Virgin and Child enthroned. It is a motif to which he returns on several occasions and which he deploys in varying compositions and contexts. Each time, the artist thereby pursues a new line and defines the role of the donor – when is portrayed – differently.

Rogier van der Weyden
Virgin and Child Standing in a Niche, c. 1440
Oil on panel, 18.9 x 12.1 cm
Vienna, Kunsthistorisches Museum,
Gemäldegalerie

ILLUSTRATION PAGE 52:
Virgin and Child (Lucca Madonna), c. 1435
Oil on panel, 65.7 x 49.6 cm
Frankfurt am Main, Städelsches Kunstinstitut
and Städtische Galerie

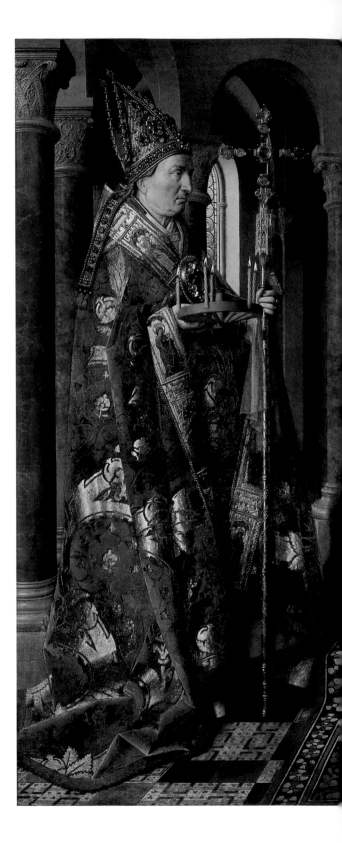

Madonna of Joris van der Paele, 1434–1436
Oil on panel, 122 x 157 cm
Bruges, Groeningemuseum

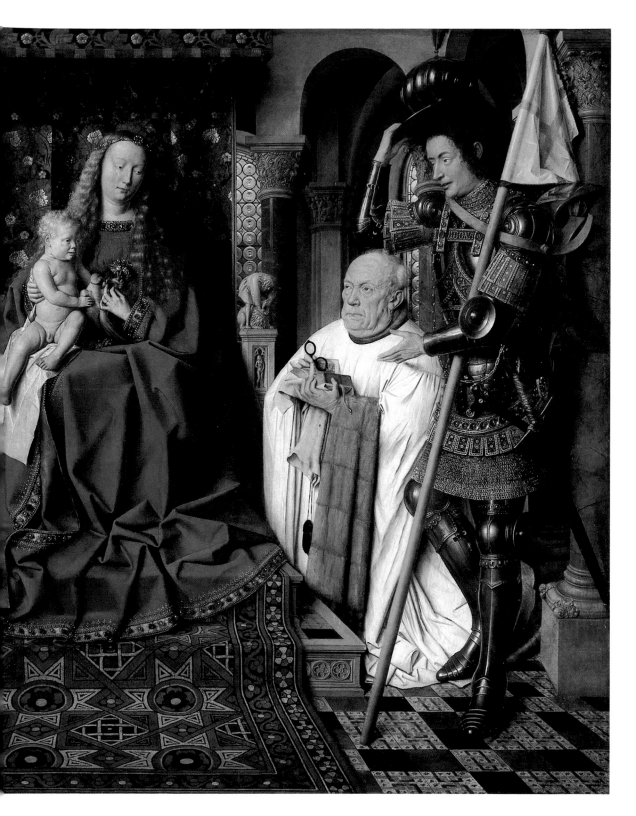

The panel of the enthroned Virgin and Child known after its provenance as the *Lucca Madonna* (p. 52), for example, adopts a compositional approach opposite to that of the *Rolin Madonna*. The commissioner and where it was originally destined are both unknown. Since the painting is documented in Tuscany in the early 19th century, van Eyck may well have painted it for a merchant from Italy.

The Virgin, who appears beneath a brocade baldachin with the Infant Christ on her lap, fills almost the entire pictorial space and dominates the surprisingly narrow interior. Facing frontally towards the viewer and nursing the Child, the Virgin is seated on a raised wooden throne whose back and arms are adorned with metal lions. A semicircular arch in the wall on the left, through which the light falls, is identified by the round window glimpsed above it as part of a Romanesque double window, of the kind found in sacred architecture. Van Eyck depicts an imaginary room in the world beyond. The motif of the paradise garden suggested by the floral pattern on the brocade is a conventional Marian symbol, and the bottle and basin also make clear reference to the Virgin. The throne is identified by the lions as the throne of Solomon (2 Chr. 9:17–19) and points to Mary's descent from the kings of the house of Judah; her robes and diadem underline her role as Queen of Heaven. She feeds the Infant Jesus as Nurse of God. Van Eyck looks back to a well-known Byzantine icon, namely the *Notre-Dame de Grâce* supposedly painted by St Luke and venerated in Cambrai. The Virgin appears lastly as the "New Eve", for the apple in the Infant's hand refers to the Fall and to Christ as the "New Adam". Van Eyck here illustrates the line of thought whereby Mary and Jesus overcome original sin and make it possible for mankind to enter Paradise.

While still working on the *Rolin Madonna,* Jan van Eyck also embarked on the *Madonna of Joris van der Paele* (pp. 54–55), his most ambitious work after *The Ghent Altarpiece*. The painting was commissioned by Joris van der Paele (c. 1370–1443), a lay canon attached to St Donatian's, the main church in Bruges. After a long career at the Roman Curia, the ageing canon returned to Bruges in 1425 a wealthy man and since performed his daily canonical duties at St Donatian's. In September 1434 he fell seriously ill and was released even from these obligations. In order to keep his canonship, and with death seemingly close at hand, he founded a chaplaincy to provide three masses on Mondays, Wednesdays and Fridays. As Vijd and Rolin had done with their own foundations, van der Paele supplemented his original foundation: in 1440 he increased the endowment capital and in 1441 received permission to fund a second chaplaincy, implemented in 1443, to say masses for the remaining days of the week.

The painting itself was probably commissioned as early as autumn 1434, as confirmed by the Latin inscription at the bottom of the frame: "Joris van der Paele, canon of this church, had this work made by painter Jan van Eyck. And he founded two chaplaincies here in the choir of the Lord. 1434. He only completed it in 1436, however." The mention of two chaplaincies indicates that the inscription was possibly amended between 1441 and 1443, when the second endowment was planned; the panel's year of completion – 1436 – was left unchanged, however. In view of its large format, it seems plausible that van Eyck and his workshop might have taken nearly two years to finish the work.

The *Madonna of Joris van der Paele* is once again a theologically complex composition in which various levels of meaning are combined. The painting shows the Virgin and Child enthroned beneath a brocade baldachin. St Donatian, as patron saint of the Bruges collegiate, is granted the heraldically more important place on the Virgin's left. Opposite him on the other side of the throne kneels

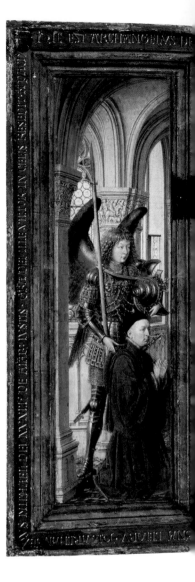

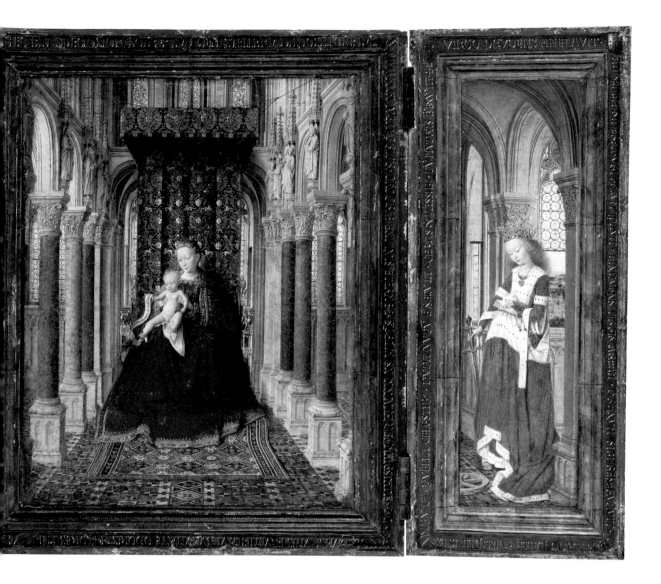

Triptych of the Virgin and Child, open, 1437
Virgin and Child with St Catherine and
Archangel Michael with a Donor
Oil on panel, 33.1 x 27.5 cm (central panel);
33.1 x 13.6 cm (wings)
Dresden, Staatliche Kunstsammlungen Dresden,
Gemäldegalerie Alte Meister

the donor, holding a prayer book and a pair of glasses in his hands. Joris van der Paele is commended to the Virgin and Child by his patron saint, St George, who is clad in a magnificent suit of golden armour. St George raises his helmet in greeting and gestures with his left hand towards the donor, who is gazing straight ahead with an absent expression.

The scenery is once more set within a sacred interior and van Eyck again takes up the formal language of Romanesque architecture. The apsidal arcades of semicircular arches identify the location as the choir of a church. The setting resembles both the choir of St Donatian's itself (now destroyed) and the Church of the Holy Sepulchre in Jerusalem, and thereby emphasizes the Eucharistic symbolism underlying the composition: the Virgin's throne namely stands on precisely the spot reserved in a real church for the altar. In this way van Eyck illustrates the idea, widespread in his day, that the Virgin symbolised the altar and the Infant Christ both Host and Eucharist. This symbolism is further underlined by

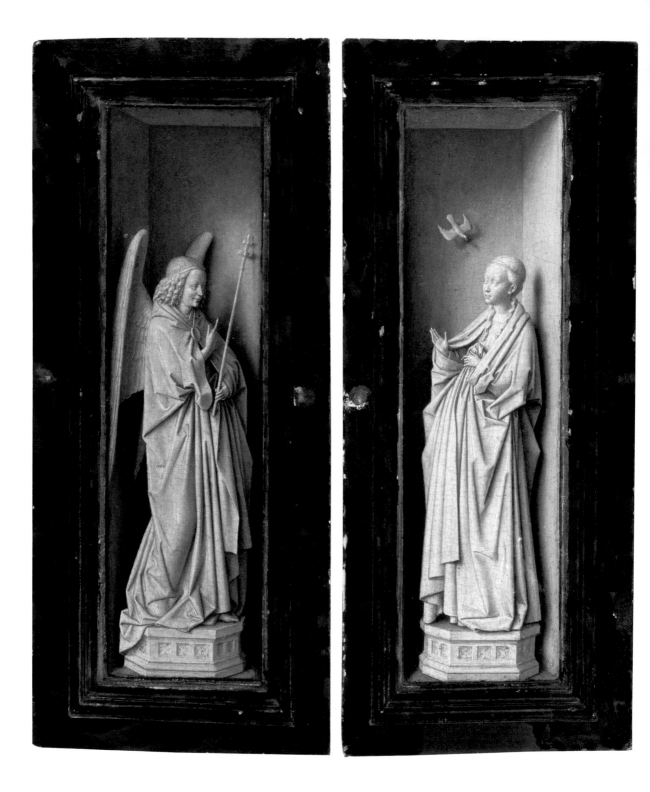

the cloth spread across the Virgin's red robes on which the naked Infant Christ is seated: even more obvious than in the *Rolin Madonna* (p. 48), the motif refers to the veiled Host during the celebration of Mass and to the sacrament of the Eucharist symbolizing Christ's death and Resurrection.

Both aspects of the Eucharist are taken up again on the left and right in the throne décor and in the figural reliefs on the capitals behind. Thus the two halves of the composition contain symmetrical references to Christ's death and Resurrection, assigning them in formal terms to St Donatian on the left and St George on the right. It is no coincidence that the attributes accompanying the two saints are respectively a reliquary cross (alluding to the Holy Cross) and the St George's flag (resembling the banner of the Risen Christ). In a compositional device already familiar from van Eyck's *Annunciation* (p. 51 right), the two spheres of death and Resurrection meet at the central axis, in other words at the point occupied by the Virgin and Child and symbolically also by the altar and the Eucharist: The formal centre of the composition and its theological focus thus become one. The fact that van der Paele is portrayed on the right, i.e. on the side of the Resurrection, reflects the hope of everlasting life that he wished to assure with his endowment.

Marian mysticism is also taken up in the inscription painted to look as if it is engraved into the frame. As in *The Ghent Altarpiece*, it cites verses from the Office of Mary's Assumption. Van Eyck illustrates the Marian metaphor of the "unspotted mirror" in a very literal way by making the Virgin's reflection appear on several parts of St George's highly polished armour. As in *The Annunciation*, the windows with their bull's-eye glazing provide another symbolic reference to Mary's purity; even the throne – reinterpreted as divine wisdom in the light of the panel's inscription – points to the *Sedes Sapientia*, the Throne of Wisdom as often depicted in earlier medieval sculpture. An unusual Marian symbol, lastly, is the parrot, regarded by theologians as a "talking" creature that could say the word "Ave". The bird thus serves as a reminder of the angelic greeting at the Annunciation, and thus of the beginning of the New Covenant. At the same time, it represents a tangible symbol of the prayers being addressed to the Virgin by the donor in the picture. For as in the *Rolin Madonna*, van Eyck is portraying not a real-life meeting, but an inner vision of the Virgin and Christ experienced by the donor in the course of his devotions. The visionary character of the scene is here less difficult to glean, and the donor-portrait provides vital clues: the direction of van der Paele's gaze and his location within the composition signal his distance from the object of his contemplation. The artist lends visual expression to this momentary pause: the canon has taken off his spectacles, turned the page of his prayer book and is reflecting upon what he has just read. His eyes are unfocused and he appears unaware either of the Virgin and Child or of St George's hand near his shoulder.

Dressed in his surplice, Joris van der Paele appears in the picture performing his duties as a lay canon for all eternity, in other words reciting his horary prayers in the collegiate church of St Donatian. In this way the panel served as a substitute for the canon himself, who for reasons of age and infirmity was no longer able to attend in person. The painting takes account of this insofar as it integrates within its composition certain holy relics venerated in St Donatian's. The church possessed relics from the Church of the Holy Sepulchre in Jerusalem: a fragment of the True Cross in a reliquary cross, and one of St George's arms, which undoubtedly explains his strange gesture of greeting. A chasuble kept in the treasury was also believed to have belonged to St Donatian himself.

As well as representing lay canon Joris van der Paele during his lifetime, the painting was also supposed to preserve his memory after his death. Van Eyck's

ILLUSTRATION PAGE 58:
Triptych of the Virgin and Child, closed, 1437
The Annunciation
Oil on panel; each 33.1 x 13.6 cm
Dresden, Staatliche Kunstsammlungen Dresden, Gemäldegalerie Alte Meister

composition takes up a theme common in sculpted epitaphs in Flanders, in which the deceased, accompanied by his patron saint, is commended to the Virgin and Child. For all its obvious sacramental symbolism, it is unclear whether the painting originally served as an altarpiece, since its former place in the church remains unknown. The panel was possibly installed over van der Paele's tomb as an epitaph. It is also conceivable that it was intended to commemorate his foundations. The artist may have deliberately composed a painting whose function is ambivalent precisely in order to fulfil all these purposes at once.

One year after completing the Bruges *Madonna of Joris van der Paele*, van Eyck executed the *Triptych of the Virgin and Child* now in Dresden (pp. 56–58). The only extant triptych in van Eyck's œuvre, it looks back to the earlier work in terms of its composition and subject, but differs from it fundamentally with respect to its small format and entirely different conception of space.

The extraordinary wealth of detail contained within the tiny triptych, the impressive handling of light and the careful application of paint bear witness – substantial restoration to the Virgin's draperies notwithstanding – to the enormous artistic and technical capabilities of the painter and his workshop. If we compare the highlights on St Michael's armour, some of them applied with the finest brush-hairs, or the minutely-observed refractions of the light passing through the bull's-eye window panes at the back of the church, with the sovereign, extremely painterly and deliberately dazzling surface of the Bruges panel, it is hard to believe that the two paintings were made almost contemporaneously. It may be assumed that van Eyck's assistants were less involved in the small Dresden Triptych than on the Bruges Madonna, and this is perhaps reflected in the signature: "Iohannis De eyck me fecit et c[om]plevit Anno D[omini] MCCCCXXXVII. ALC IXH XAN". In making a distinction between "made and completed" (*fecit et complevit*), the artist may be indicating that he personally finished the work, something echoed by the inclusion of his personal motto, "As I can", up till now found only on his portraits.

The tiny left wing of the open triptych depicts an unknown donor with Archangel Michael in the ambulatory of a Romanesque church. He is dressed in the Burgundian fashion and kneels reverently before the Virgin and Child, who are enthroned beneath a brocade baldachin in the nave on the central panel. The Infant Christ holds a banderole bearing a quotation from St Matthew's Gospel: "Discite a me, quia mitis sum et humilis corde" (Learn of me, for I am meek and lowly in heart; Matt. 11: 29). On the right-hand wing, St Catherine of Alexandria appears with her attributes of the sword, book and wheel; visible through the ambulatory window behind her – albeit only with a magnifying glass – is a minutely detailed landscape including clusters of buildings.

All three panels are set within painted imitation bronze frames with "engraved" inscriptions running around them. Once again these include excerpts from the Office of the Assumption, together with fragments of prayers from the offices of St Michael and St Catherine. Here, too, the inscriptions make clear the otherworldly character of the picture. The symbolic allusions already present in the *Rolin Madonna* and the *Madonna of Joris van der Paele* to Ecclesia and altar, Sacrament, death, Resurrection, Heavenly Jerusalem and Paradise, as well as their prefigurations in the Old Testament, are explored in new variations on the open, feast-day side of the triptych. At the formal level, the three-part structure of the composition clearly separates the portrait of the donor from the apparition of the Virgin and so plainly articulates the indirect nature of her relationship to the donor in prayer. Once again, theological correlations familiar from biblical

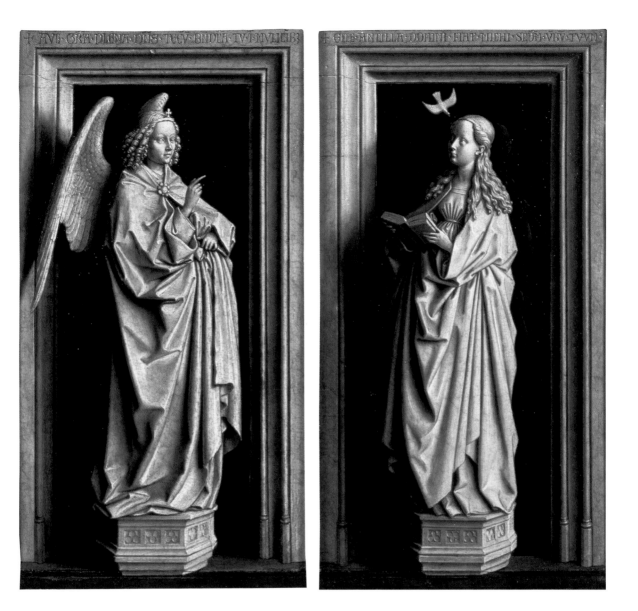

+ AVE GRA PLENA DNS TECV BNDCA TV IN MVLIERB;

+ ECCE ANCILLA DOMINI FIAT MICHI SCDM VBV TVVM

Diptych of the Annunciation (detail), c. 1436
Oil on panel, each 38.8 x 23.2 cm
Madrid, Museo Thyssen-Bornemisza

Van Eyck was a master of illusionism. Imitation stone statues of Archangel Gabriel and the Virgin Mary rise from octagonal pedestals and seemingly cast their shadows against stone architraves. The dark background imitates a smoothly polished surface, within which the painted stone figures appear to be mirrored.

exegesis and contemporary sermons are illustrated within the composition with supreme artistic and technical mastery. Van Eyck was surely working here for an educated client who was able to appreciate his intellectual and technical prowess – even in the two imitation statues and hovering dove of the Holy Ghost which make up the grisaille *Annunciation* on the triptych's outer wings (p. 58).

The commissioner of the *Triptych of the Virgin and Child* is unknown: although the coats of arms on the frame are original, they are badly damaged and partly overpainted. At least one of the shields belongs to the Giustiniani family, Genoese patricians who in the 14th and 15th century established themselves as merchants in Bruges. The triptych undoubtedly found its way to Liguria before the end of the 15th century, where it served the so-called Maestro del Annunciazione del Monte as a model for his Virgin and Child altarpiece in Pontremoli. In view of

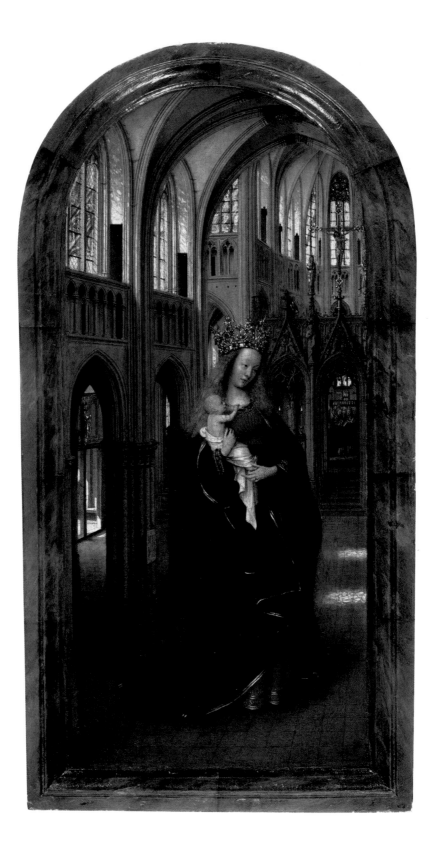

its format, the work probably served rather as a travelling altarpiece than as a private devotional triptych. Portable altars were the privilege of the clergy, the patriciate and the nobility, amongst whose ranks the donor – in view of his clothing – must have counted. The use of such *altare portabile* – which contained a consecrated piece of wood – required the authorisation of the Curia and was strictly regulated.

The Dresden Triptych was not the only work that van Eyck painted for a Genoese merchant. Particularly famed in Italy was a triptych he had painted for Giambattista Lomellini, and which by the mid-1440s had passed into the possession of King Alfonso V in Naples. It was described in detail by Bartolomeo Facio in his *De viris illustribus* of 1456. According to Facio, the *Lomellini Triptych* comprised a central Annunciation flanked on the left by St John the Baptist and on the right by St Jerome in his Study; the portraits of the donor and his wife could be admired – as on *The Ghent Altarpiece* (pp. 28, 33) – on the exterior shutters. Echoes of the *Lomellini Triptych*, which was probably destroyed as early as the start of the 16th century, are found in Genoa and Naples. Colantonio's *St Jerome in his Study* (p. 79) is assumed to be inspired by van Eyck's lost panel of the same subject, and the triptych's Annunciation was probably the starting-point for the monumental fresco that Jos Amman of Ravensburg executed in 1451 in the Genoese monastery of Santa Maria di Castello.

Two undated works by van Eyck deserve consideration in conjunction with the *Triptych of the Virgin and Child*: the Madrid *Diptych of the Annunciation* (p. 61) and the Berlin *Madonna in a Church* (p. 62). The latter employs a very small format, sufficient in itself to invite comparison with the diminutive Dresden triptych: the two works have long been assigned to the same stage of the artist's development. The *Madonna in a Church* shares with the triptych its delicately painted surface, a similar interest in the dramaturgical properties of light, and lastly a feel for architecture. Whereas van Eyck usually tended towards Romanesque church interiors, here he deliberately associated the Virgin and Child with the modern Gothic cathedral architecture, in order to illustrate the metaphor of the Blessed Virgin Mary as Ecclesia. The precision with which van Eyck details the architecture is quite remarkable: different building phases can be recognised within the triforium, and through the almost transparent windows in the clerestory we look out onto solid flying buttresses; there are even cobwebs in the spandrels of the vault. Nevertheless, we face a fantastical structure, whose choir extends above the height of the nave. The enormous scale of the figure of the Virgin – her head reaches the level of the triforium – evokes her identity with the building: van Eyck is literally portraying not the Madonna in a Church but the Madonna as the Church.

The Berlin panel also makes masterly use of the compositional potential of light and grants it a symbolic power. Sunlight falls through the church windows onto the floor beside the Virgin, and the letter sequences "Sol" and "lu" – fragments of the Latin *sole* (sun) and *lucis* (light) – are also worked in gold thread along the hem of her dress; they refer to the Office of the Assumption. The Virgin's magnificent robes and crown identify her as the Queen of Heaven.

The motif of the Coronation of the Virgin is also visible in the right-hand pediment above the rood screen, with an Annunciation in the pediment to its left and a statue of the Virgin and Child beneath it, standing on an altar in a niche. Even bolder are the associations implied on the vertical axis: seven steps – a symbol of the Apocalypse – lead up through the rood screen to an altar shrine, in front of which two singing angels – the heavenly choir – are standing. Above

ILLUSTRATION PAGE 62:
Madonna in a Church, c. 1438
Oil on panel, 31 x 14 cm
Berlin, Staatliche Museen zu Berlin –
Preußischer Kulturbesitz, Gemäldegalerie

The Virgin is shown as enormously tall in relation to the church interior: van Eyck is here depicting not the Madonna in a Church, but the metaphor of Mary as the Church. The original frame was lost at the end of the 19th century when the diminutive panel was stolen from its Berlin museum.

them appear the Coronation of the Virgin and finally the triumphal cross, which here alludes to both Crucifixion and Redemption. Another facet of the Virgin is implied by a gilt statue of a Mother of Sorrows on top of the rood screen, directly above the figure of Solomon, one of Mary's forebears. Van Eyck has deliberately constructed his entire composition around the role of the Virgin in the history of salvation: a pictorial focus which leaves even St John the Evangelist – strictly speaking an integral part of Gothic triumphal crosses – out of the picture.

The *Madonna in a Church*, whose original frame was stolen in the 19th century, is probably a fragment. Two surviving copies, one by the Ghent Master from 1499 and another by Jan Gossaert, both show the *Madonna in a Church* as the left wing of a devotional diptych. It seems likely, therefore, that Jan van Eyck's panel was once accompanied by a right-hand wing depicting the donor.

If the *Madonna in a Church* is related to the feast-day side of the Dresden *Triptych of the Virgin and Child* (pp. 56–57), its exterior (p. 58) reveals parallels with the *Diptych of the Annunciation* today in Madrid (p. 61). The diptych ranks among van Eyck's most sophisticated works and demonstrates not least his knowledge of the optical theories of his day. Employing solely the means of art, the painter annuls the planar reality of the picture and ostentatiously replaces it with a masterly illusionism that aims to impress. He thereby takes up the art-theoretical debate surrounding the merits of painting versus sculpture and assumes that his viewers are familiar with anecdotes about the artists of antiquity. Inside their frames, which are painted to look like red marble, the Virgin and Archangel Gabriel appear as colourless stone statuettes, each standing on an octagonal plinth against a flat niche bounded by an imitation stone surround. Van Eyck not only suggests freestanding stone sculpture but at the same time also imitates, in fact, the grisaille exteriors of a winged altar.

This is not the only source of confusion when looking at the diptych: both plinths project out beyond the painted edge of their niches, while the statuettes cast a shadow to the left, onto the mouldings of the imitation stone surround. The artist is here deliberately creating a *trompe-l'œil* effect that, like the reflections on the polished black stone apparently forming the back of the niche, increases the illusion of physically tangible three-dimensional sculpture. This illusion is at the same time pierced, however, by the dove of the Holy Ghost hovering freely in space: the painter demonstrates the superiority of painting and settles the competition with sculpture in his own favour.

Adopting a compositional strategy similar to that of the *Madonna in a Church*, van Eyck establishes in his *St Barbara* (p. 65) clear visual links between the popular martyr and her attribute of the tower. According to legend, Barbara's father had her walled up inside a tower when she converted to Christianity. The solid Gothic tower – whose architecture resembles Cologne Cathedral, at that time still under construction – dominates the background, surrounded by anecdotal scenes of Gothic builders at work against a sweeping landscape. Although signed on the original frame with "Joh[ann]es de Eyck me fecit. 1437", it is not strictly speaking a panel painting but a detailed drawing carried out with a brush on a prepared ground. Whether it represents the underdrawing of an unfinished work, or whether it was intended as an autonomous drawing, remains the subject of dispute. And yet there is much to suggest that *St Barbara* represents an unfinished painting by van Eyck. This raises the issue of the signature and year of completion given on the frame. These appear in the usual form of "chiselled" letters that were painted onto the frame before the drawing was even begun – a practice which poses some urgent questions about the status of van Eyck's signatures with

Workshop of Jan van Eyck
Madonna at the Fountain, c. 1441
Oil on panel, 21.3 x 17.2 cm
The Hague, Mauritshuis (on loan from
a private collection)

ILLUSTRATION PAGE 67:
Madonna at the Fountain, 1439
Oil on panel, 19 x 12.5 cm
Antwerp, Koninklijk Museum voor Schone
Kunsten

The *Madonna at the Fountain* was intended
for private devotion. Executed two years before
van Eyck's death, it was subsequently copied by
members of his workshop (p. 66) and provided
a model for artists such as Gerard David and
Adriaen Isenbrandt even in the 16th century.

regard to pictorial invention, execution and dating. In the case of *St Barbara*, it
must be concluded that "Joh[ann]es de Eyck me fecit. 1437" cannot refer to the
panel's actual completion by the master himself. As a signature, it perhaps as-
sumes a function quite the opposite to the signatures of later artists: rather than
pronouncing a work completely finished, it implies a distinction between the
design of a picture and its subsequent execution by other hands, a distinction
similarly employed in the graphic arts in the 16th century.

The inscription on the *Madonna of Joris van der Paele* (pp. 54–55) sheds no
light on the question of the status and significance of the signature, since it refers
primarily to the donor's "foundation" and only secondly to the painting itself.
On the other hand, the inscription on the frame of the Dresden Triptych (pp.
56–57) suggests that the actual moment of completion is denoted by the word
complevit, sometimes accompanied – as on his portraits – by the artist's motto
"ALC IXH XAN".

Precisely this combination is found in the inscription on the frame of the
Madonna at the Fountain (p. 67), dated 1439. The small devotional panel was
made in the same year as the *Portrait of Margarete van Eyck* (p. 36) and is the
master's last dated painting. The small panel shows the Virgin, with the Child
in her arms, in front of a grassy bench in a garden enclosed by a flowering hedge.
She is standing on a cloth of honour held up by two angels. In the left-hand fore-
ground is a brass fountain crowned by a lion. These motifs would by no means
have been unfamiliar to 15th century viewers as they were reminiscent of contem-
porary gardens. The angels nevertheless clarify that we are looking at a celestial
realm which implies an allegorical reading. The grassy bench, the garden full of
flowers and the floral patterns on the cloth of honour all represent the paradise
garden; the brass fountain, on the other hand, refers both to the *fons hortorum*
("garden fountain") of the Song of Songs – i. e. to the Virgin as the source of
flowers – and to the apocalyptic motif of Christ as the fountain of life which, as
in *The Ghent Altarpiece*, feeds the river of life. The pose of the Virgin and Child
also looks back to the Byzantine icon of the *Maria eleusa*, the Virgin of Tender-
ness, and thereby to Mary's role as Mother and Nurse of God. The rosary in the
Infant's hand serves as a visual reminder of the prayers that were addressed to the
Virgin in front of this little devotional panel.

The symbolism of the *Madonna at the Fountain* is similar to other Marian
paintings by van Eyck and incorporates motifs that also appear in the devotion-
al works of other Early Netherlandish masters, such as Rogier van der Weyden.
What makes this tiny panel nonetheless surprising is the extraordinary concen-
tration of these symbols. A number of later copies testify to the fact that the
Madonna at the Fountain was accessible at least to a limited public. The painting
may have been held in particularly high esteem and possibly enjoyed the privil-
ege of a letter of indulgence. Most of the copies were done at the beginning of
the 16th century in the circle of Gerard David and Adriaen Isenbrandt, suggesting
that the small panel was at that time still located in Bruges. Another copy of the
Madonna at the Fountain, deviating from the original only in its slightly altered
proportions, was probably executed by van Eyck's workshop after the master's
death in 1441 (p. 66). This may be the copy that is listed in Malines in a 1521 in-
ventory of Margaret of Austria's art collection.

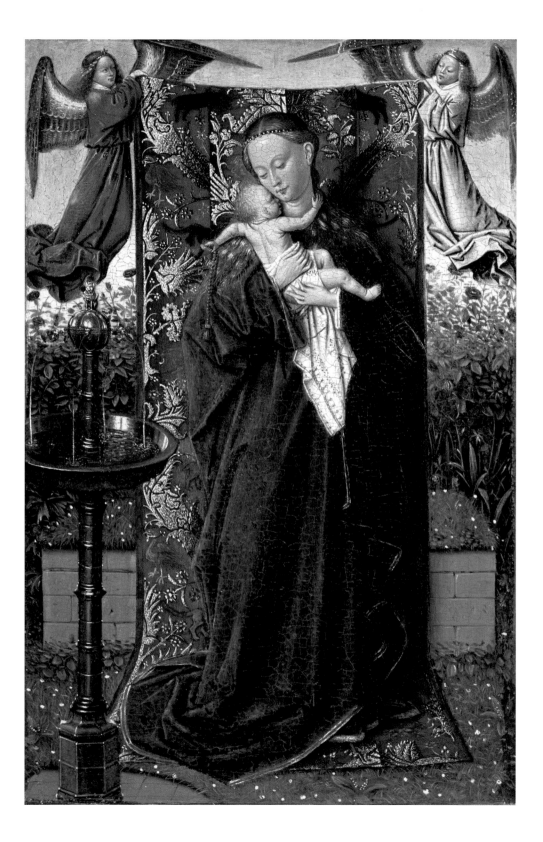

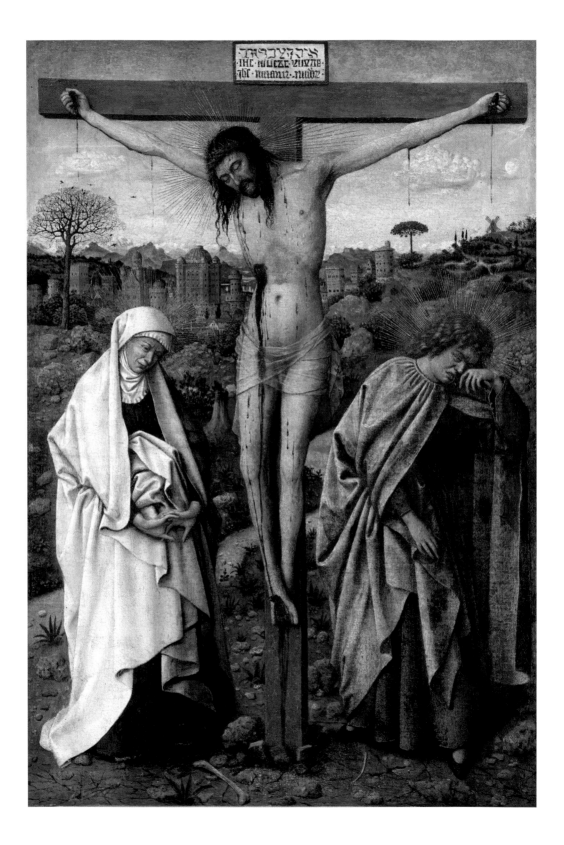

Jan van Eyck and his Workshop

Jan van Eyck died in summer 1441. A number of commissioned works were still unfinished and were completed posthumously by members of his workshop. It was not usual to close down a workshop immediately after the master's death; his widow would often carry on the business with the help of journeymen and assistants. One of Jan van Eyck's closest collaborators seems to have been his brother Lambert, who even signed a painting – the *Portrait of Jacoba of Bavaria* (p. 11), which only survives in a few copies. Lambert seems to have continued running van Eyck's workshop together with his widow until the end of the 1440s, when the house in Bruges was sold. Whether Margarete van Eyck was herself active as an artist is uncertain; the historical tradition according to which Jan van Eyck's sister Margarete was also a paintress could in fact refer to his widow.

Documents reveal that Jan van Eyck's workshop for a time numbered twelve people. Not all of his assistants would have been employed on draperies, brocades, backgrounds etc.; some would have been assigned practical tasks such as polishing prepared grounds or grinding pigments.

Only one assistant, known as the Master of the Grimacing St John, can be identified in several works. He owes his provisional name to an imitation stone statue of *St John the Baptist* occupying the left wing of a grisaille diptych, whose opposite wing depicts the *Virgin and Child* (p. 71). In their extrovert corpulence, the folds of the draperies, contrasts of light and shade and volumes are different from the elegant grisailles of the conceptually superior Madrid *Annunciation* (p. 61) and the outer panels of the Dresden *Triptych of the Virgin and Child* (p. 58). In stylistic terms the diptych is still related to *The Adoration of the Lamb* (pp. 20, 21) and resembles figural drawings of *Apostles* probably by the same hand (p. 69). Lastly, this same assistant may also be attributed with the *Christ on the Cross with the Virgin and St John the Evangelist* (p. 68), whose figural style follows on closely from the diptych.

Another assistant may be identified in the *Ince Hall Madonna* (p. 73). Although fundamentally shaped by the style of van Eyck, this hand demonstrates its independence above all in its bold use of light and shade. The *Ince Hall Madonna*, which is closely related to other Marian paintings by van Eyck in terms of motifs and typology, represents a replica of a lost original. Unlike other copyists, its artist has thereby adhered closely to Jan van Eyck even in his treatment of the surface, suggesting that he had perfectly assimilated his master's technique over many years.

Workshop of Jan van Eyck (Master of the Grimacing St John)
The Twelve Apostles: St Paul, 15th century
Pen and pencil on paper, 20.3 x 18.3 cm
Vienna, Grafische Sammlung Albertina

ILLUSTRATION PAGE 68:
Workshop of Jan van Eyck (Master of the Grimacing St John)
Christ on the Cross with the Virgin and St John the Evangelist, c. 1435
Oil on canvas (transferred from panel), 43 x 26 cm
Berlin, Staatliche Museen zu Berlin, Gemäldegalerie

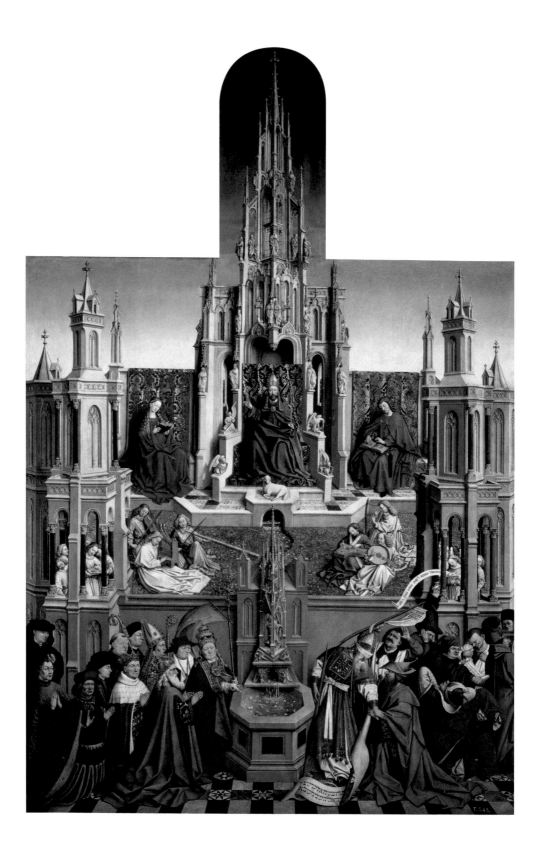

Amongst the key works connected with the Bruges workshop is *St Francis
Receiving the Stigmata*. It survives in two versions (pp. 76, 77), both from the van
Eyck workshop and identical virtually down to the smallest detail, albeit with
differences in their format, technique and support. The Turin version, painted
in oil on panel, reveals pentimenti and is therefore considered to be the original.
The considerably smaller version in Philadelphia was painted in oil on vellum
and glued to panel. Its palette is more intense, but it is executed in a technique
different to that of the Turin version. The highlights in the Philadelphia painting,
for example, are not built up from thin layers of glaze, as characteristic of the in-
tact surfaces of works by van Eyck, but are applied superficially in line with the
techniques of manuscript illumination. They thereby achieve an effect significantly
richer in contrast but at the same time less subtle. Analysis of the wood support
onto which the vellum is glued has shown that the Philadelphia picture, too,
was done in the van Eyck workshop. Indeed, it was cut from the same tree as the
panels on which van Eyck painted the portraits of *Baudouin de Lannoy* (p. 39)
and *Giovanni di Nicolao Arnolfini* (p. 41), and therefore probably belonged to a
stock of wood held in the van Eyck workshop.

St Francis Receiving the Stigmata must once have existed in several versions.
The Turin panel falls closer in line with van Eyck's œuvre, but whether the mas-
ter actually provided the preliminary design for the subject is doubtful. Overall,
the composition should probably be seen as a product of the workshop. St Fran-
cis's feet are so bizarrely placed as to look like a foreign body, but the motif in
fact derives originally from *The Ghent Altarpiece*: the feet of the prophets kneel-
ing before the Lamb have a similar – albeit reversed – position (p. 20). The kneel-
ing figure of St Francis also recalls the donor portrait of *Nicolas Rolin* (p. 48).
Other motifs – including landscape details – were presumably drawn from the
wealth of source material that remained accessible to the members of the work-
shop.

Workshop of Jan van Eyck (Master of the
Grimacing St John)
*Diptych of St John the Baptist and the Virgin
and Child*, c. 1435
Oil on panel, each 38.3 x 23.5 cm
Paris, Musée du Louvre

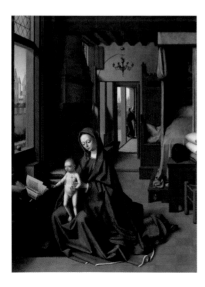

The use of such source material is evident in the *Madonna of Jan Vos* (pp. 74–75). In a similar fashion to the *Madonna of Joris van der Paele* (pp. 54–55), the small panel depicts the Virgin and Child surrounded by St Barbara with the kneeling cleric and St Elizabeth of Hungary. The saints and donor – the Carthusian monk Jan Vos – occupy a loggia bounded by arcades that open out onto an expansive background landscape. The figure of the donor is modelled on the same design as Chancellor Rolin, and the tiles, decorative capitals and patterned brocade are all accessories that feature in van Eyck's other works. The landscape background borrows most clearly of all from the treasury of images bequeathed by the master: the city view on the right with its characteristic bridge motif, for example, derives from the universal landscape of the *Rolin Madonna* (p. 48).

From the dates of the donor's career, it is evident that the *Madonna of Jan Vos* must represent a posthumous work by the van Eyck workshop. Jan Vos arrived in Bruges at the earliest in March 1441 to take over as prior of the Carthusian monastery of Genadedal, a post he would hold for nine years. Whether Jan Vos was in time to commission the painting from Jan van Eyck in person, or whether he had to go straight to the workshop, remains uncertain. Documents show that the panel was in use as an altarpiece in the charterhouse chapel by September 1443. The execution of the small-format work must therefore have fallen largely to the workshop after the master's death. When he returned to Utrecht in 1450, Jan Vos took the panel with him, leaving behind a "copy" for the charterhouse in Bruges. For this he turned to Petrus Christus, established in Bruges since 1444. The choice of Petrus Christus may have been influenced less by the latter's reputation than by the fact that the van Eyck workshop then was no longer in operation.

Christus' copy, the so-called *Exeter Madonna* (p. 75 top), qualifies as an independent interpretation rather than a faithful imitation of the original. The artist nevertheless looked back not only to the Bruges painting, but also – in the universal landscape, the Virgin's pose and the airy tower interior – to the lost *Madonna of Nicolas van Maelbeke* that van Eyck had left unfinished in his workshop on his death.

Van Maelbeke was provost of the collegiate church of St Martin's in Ypres. As one of the most influential clerics in the town, he moved in Burgundian court circles and also maintained close links with St Donatian's in Bruges. He must have been familiar with the *Madonna of Joris van der Paele* when he commissioned his own altarpiece from van Eyck, which he intended to be placed in front of his tomb in the upper choir of St Martin's. It appears that the work was only finally installed on the occasion of the donor's funeral in 1445. The commission was probably awarded not long before van Eyck's death and hence its completion once again fell to the workshop.

The appearance of the lost altarpiece is preserved in a copy made in the Baroque period, allowing the state of the work at van Eyck's death to be reconstructed. Two 15th century drawings (p. 75 bottom) – one by Petrus Christus – record van Eyck's design. They show the apse of a Romanesque choir in which the Virgin and Child on the right are standing in front of a kneeling donor on the left. The arches of the vaulted ceiling are carefully composed with a compass, the decorative capitals are picked out in detail and the varying shades of the stone pilasters and columns are indicated by hatching of different density. The folds of the Virgin's robes are delineated in detail and the faces of the Virgin and Child are carefully copied. In both drawings, however, the figure of the donor and the background as a whole are shown only in rudimentary outline. On the basis of small differences between the two sheets, it is clear that both draughts-

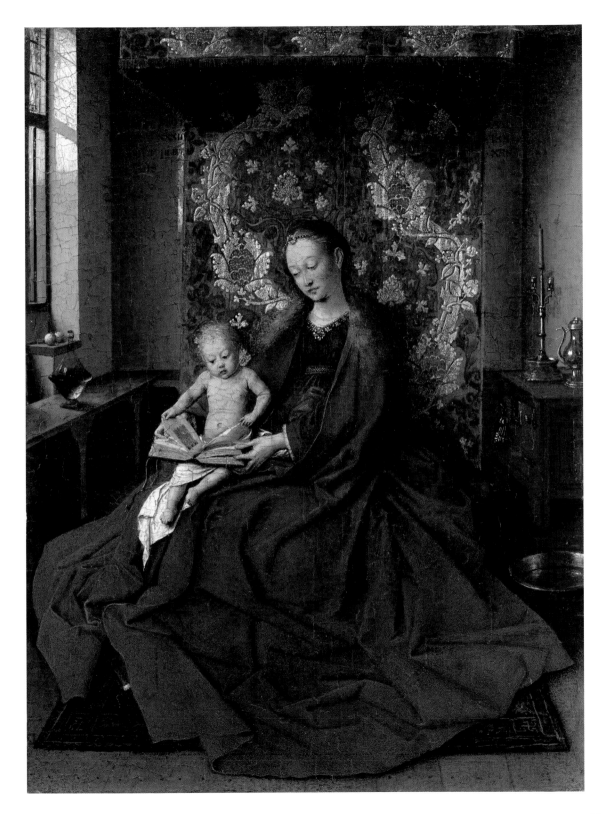

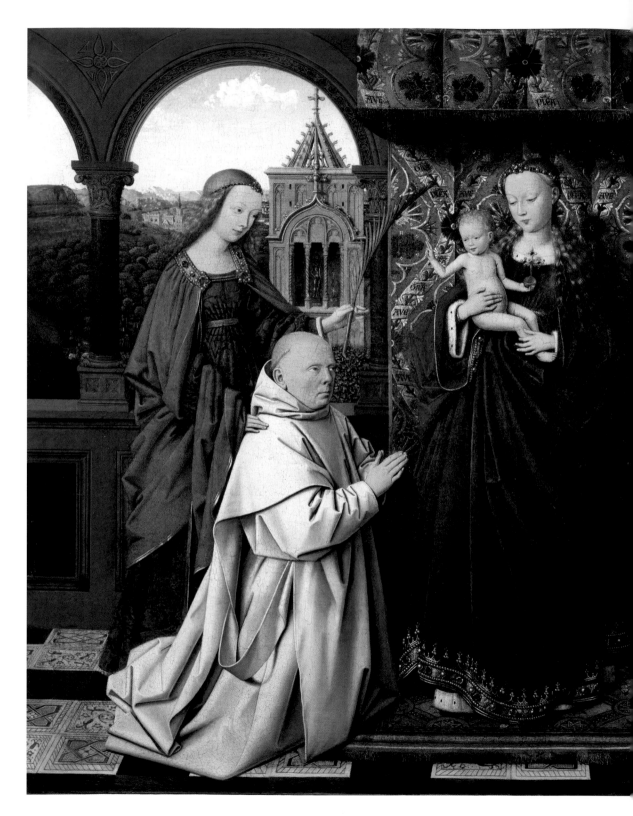

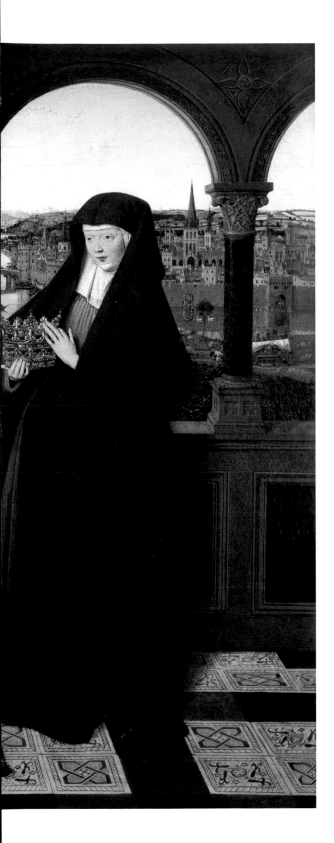

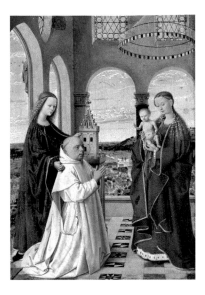

Petrus Christus
Madonna of Jan Vos (Exeter Madonna), c. 1450
Oil on panel, 19 x 14 cm
Berlin, Staatliche Museen zu Berlin,
Gemäldegalerie

After Jan van Eyck and Workshop
Madonna of Nicolas van Maelbeke, c. 1445
Silverpoint on paper, 13 x 9.9 cm
Nuremberg, Germanisches Nationalmuseum

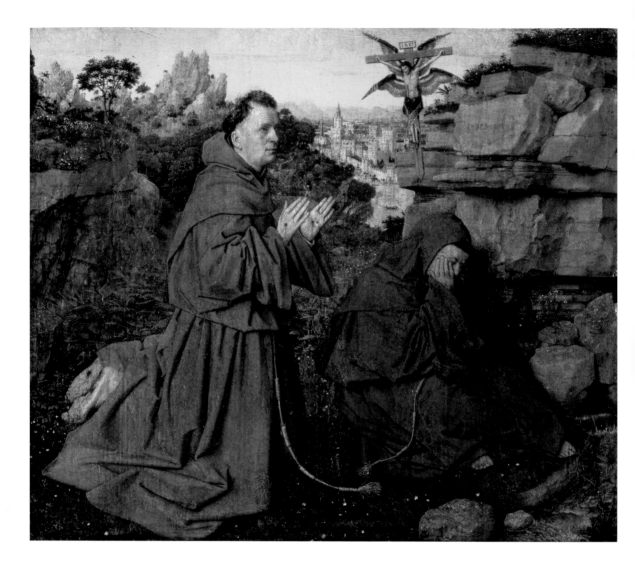

Jan van Eyck and Workshop
St Francis Receiving the Stigmata, c. 1440
Oil on panel, 29.3 x 33.4 cm
Turin, Galleria Sabauda

Van Eyck's St Francis composition existed in several versions. One is documented in 1448 in the collection of the Spanish painter Juan Rexach. Another was owned by the Adornes family, who had two copies made of it in 1470. The painting represents an important example of van Eyck's landscape painting.

men referred to the same prototype independently of one another, and that this original had in places already progressed to the painting stage. The background, tiled floor and donor figure, on the other hand, probably existed only as preliminary drawing. Both sheets were undoubtedly executed in front of the unfinished painting in van Eyck's Bruges workshop, before the sudden death of the donor obliged the members of the workshop to complete the provost's magnificent chasuble and the landscape.

The workshop also seems to have issued its own paintings in the style of the master on the basis of designs and studies of individual motifs. *St Jerome in his Study* (p. 78) perhaps ranks among those apocryphal products of the posthumous van Eyck workshop. Its date is established by the year 1442 [?] given in the background, which – although damaged – belongs to the original substance of the painting. The small-format composition depicts the saint as a cardinal in his study. An hourglass and a folded letter are, alongside writing utensils, visible on his desk. Pen and ink, books and lectern point to the saint's scholarship and to

his role as the translator of the Bible. The glass carafe and rosary, both familiar symbols of Mary and Christ, refer to the theme of his writings. The astrolabe and hourglass evoke a specific point in time and together with the letter reveal to whom the painting is addressed: Niccolò Albergati, the cardinal of Santa Croce in Gerusalemme. This emerges not only from the writing that can be read in the letter, but also from the astronomical reading on the astrolabe, which corresponds to the Peace of Arras.

Whether *St Jerome in his Study* was indeed destined for Cardinal Albergati, who died in 1443, must remain a matter of speculation. What is certain, however, is that the diminutive painting found its way to Florence, where it is documented in 1492 in an inventory of the Medici collection. The picture, which is listed as the "opera di Giovanni di Bruggia" (the work of John of Bruges), must already have been known to Florentine artists, for Ghirlandaio and Botticelli, at least, show themselves clearly influenced by the Eyckian painting in their own frescoes for the Church of Ognissanti.

In terms of its painting technique, *St Jerome in his Study* reveals certain peculiarities. While some of these are due to early restorations, others appear genuine. The picture was not painted directly onto panel, but onto paper that was glued to wood. Its additive technique, reminiscent of manuscript illumination, differs correspondingly from van Eyck's more subtle method of applying the paint in multilayered glazes, a process that lent his palette its characteristic luminosity. The technique employed in *St Jerome in his Study* finds a parallel only in the Philadelphia version of *St Francis Receiving the Stigmata* (p. 77).

Both paintings occupy a special position within the œuvre of van Eyck and his workshop and suggest that, after the master's death, the members of his workshop did not restrict themselves solely to panel painting, but also devoted themselves to manuscript illumination. Confirmation is found in a miniature of *St Thomas Aquinas* (p. 80 left) from the *Turin Hours*, a magnificent codex that was destroyed by fire in 1904. This miniature almost perfectly resembles the *St Jerome* by the van Eyck workshop and also takes the motif of the hovering crucifix from *St Francis Receiving the Stigmata*.

The close relationship between *St Jerome*, which is a panel painting created with the means of manuscript illumination, and the miniature of *St Thomas Aquinas* supports the argument that the same artist painted both works. It also indicates that the boundaries between painting and illumination were disappearing: members of van Eyck's workshop were producing both miniatures and panel paintings. By the middle of the 15th century, Eyckian compositions were being disseminated above all in Flemish miniatures. With their small formats and microscopic details, the paintings from Jan van Eyck's final years possess an affinity with the creative constraints imposed by manuscript illumination; during this period, moreover, van Eyck paid Jean Creve out of his own pocket to paint initials for a manuscript destined for the Burgundian duke. Is it conceivable that Jan van Eyck himself, before his death, contributed miniatures to illuminated manuscripts, which after all ranked amongst the most prized objects of Burgundian patronage? There is no doubt that the many Eyckian miniatures in the so-called *Turin-Milan Hours* have a vital bearing both on the question of Jan van Eyck's activities as an illuminator and on the thorny issue of what should be attributed to his posthumous workshop.

Since the van Eyck brothers were first credited with a number of miniatures in the *Turin Prayer Book* in 1901, the question of their dating and attribution as well as the history of the manuscript's creation have formed some of the most

Workshop of Jan van Eyck (Master of the Philadelphia St Francis)
St Francis Receiving the Stigmata, c. 1445
Oil on parchment on panel, 12.7 x 14.6 cm
Philadelphia, PA, Philadelphia Museum of Art.
John G. Johnson Collection, 1917

disputed areas of research. It is only thanks to good fortune that the miniatures
were even photographed, for in 1904 the codex was destroyed in a fire. Shortly
afterwards, however, a second part of the manuscript was discovered in Milan
and was published in 1910 as the *Milan Hours*. Although it was clear early on that
both fragments originally formed part of the *Très Belles Heures de Notre-Dame*,
documented in Jean de Berry's collection in 1413 and today housed in Paris, the
two Eyckian fragments continue to be known under the joint name of the *Turin-
Milan Hours*.

Jean de Berry's prestigious book project was entrusted to various illuminators,
including several Paris workshops and the Limburg brothers. In 1413 the finished
first section, containing a book of hours and a calendar, was separated from the
rest of the manuscript. In the 1430s the remaining two sections, a missal and a
prayer book both only partially illuminated, reached Flanders. There, various
artists from van Eyck's workshop and from amongst his followers worked on their
decoration until 1450.

The pages of the *Turin-Milan Hours* thus bring together Parisian illuminators
from the period around 1400 and Flemish miniaturists from the period around

1450. As a means of distinguishing between the various artists and indicating the chronological order in which the codex was decorated, the miniaturists were once assigned letters of the alphabet, from A to K. Hands G and H have long been problematical, with some researchers claiming to see in them the work of Hubert van Eyck or even early efforts by Jan van Eyck, while the artists subsumed under letters I to K have already traditionally been identified as painters in Jan van Eyck's workshop and circle.

Today there is widespread consensus that Jan van Eyck executed a number of miniatures in the *Turin-Milan Hours*. The *Mass of the Dead* (p. 82 right) accompanying the Requiem mass in the Missal not only recalls the *Madonna in a Church* (p. 62), but identifies itself – in the astonishing thickness of its paint – to be the work of a panel painter who is not entirely familiar with manuscript illumination. When van Eyck commenced work on the sheet, the position of the text block and ornamental border were already laid out and a gold-leaf border framed the space to be filled by the main illustration. The artist overcomes these constraints with a slanting view into a Gothic choir: he boldly continues the crossing arch beyond the upper edge of the gilt border, while abruptly ending the vault compartments at the same point. Above the gilt bar, he depicts a brick wall that already appears to be showing signs of ageing; the masonry indicates that the church is still under construction and at the same time offers a cross-section through the vault. In the bas-de-page illustration beneath the opening lines of the Requiem, the painter depicts a cemetery scene. Chanting priests are followed by mourners at a distance:

ILLUSTRATION LEFT:
Workshop of Jan van Eyck
St Thomas Aquinas, c. 1445
Turin-Milan Hours
Tempera on parchment, 29 x 19 cm
Turin, Biblioteca Nazionale Universitaria
(destroyed by fire)

ILLUSTRATION RIGHT:
Workshop of Jan van Eyck and Petrus Christus (?)
Virgo inter Virgines/Adoration of the Lamb,
c. 1440–1450
Turin-Milan Hours
Tempera on parchment, 29 x 19 cm
Turin, Biblioteca Nazionale Universitaria
(destroyed by fire)

ILLUSTRATION PAGE 81:
Workshop of Jan van Eyck (Master of the Philadelphia St Francis)
The Agony in the Garden, c. 1440–1450
Turin-Milan Hours
Tempera on parchment, 26 x 20 cm
Turin, Museo Civico

os autem gloriari oportet in aute
domini nostri ihesu xpisti in quo est
salus uita et resurrectio nostra per que
saluati et liberati sumus. ps. deus m

ILLUSTRATION LEFT:
Birth of St John the Baptist/Baptism of Christ,
c. 1435–1440
Turin-Milan Hours
Tempera on parchment, 26 x 20 cm
Turin, Museo Civico

The *Birth of St John the Baptist* and the *Mass of the Dead* (right) are the only surviving miniatures that are considered autograph works by van Eyck. It is likely that they were painted only towards the end of his life, and not prior to *The Ghent Altarpiece*.

ILLUSTRATION RIGHT:
Mass of the Dead, c. 1435–1440
Turin-Milan Hours
Tempera on parchment, 26 x 20 cm
Turin, Museo Civico

Van Eyck skilfully adopts here a particularly low point of view in order to create a sense of depth even in such a narrow space.

The page including the *Birth of St John the Baptist* (p. 82 left) was undoubtedly also painted by Jan van Eyck. The thickness of the paint is again noticeable in the main miniature, whose interior reveals close parallels with *The Arnolfini Marriage* of 1434 (p. 45). Here, however, the stage-like room is square and is seen from above. Particularly spectacular for its masterly lighting is the depiction of the reading Zacharias in the next room; despite its tiny format it foreshadows Dutch genre paintings of the 17th century. The *Birth of St John the Baptist* resembles van Eyck's Marian paintings in its incorporation of complex symbolism: the "birth of the Voice", i. e. the last prophet, is subtly contrasted with the "silence of the Law", embodied by the figure of Zacharias, who is reading beneath a mural of Moses. Behind the maid seen in rear view, a small child points towards the person who is the real focus of the scene, namely Mary. She is approaching from the right, and carries the ointment with which she will anoint the last prophet and sanctify his prophecy. On the dresser in front of her, bread and wine refer to the Eucharist and death of the future Saviour. The *Baptism of Christ* at the bottom of the page ranks amongst the most impressive landscapes of Early Netherlandish painting. Here, too, van Eyck uses a low horizon in order to show a river apparently disappearing into the distance. A visual link is established between the bas-de-page and the illuminated initial D, containing the figure of God the Father, by means of the dove of the Holy Ghost, which descends from the initial to the newly baptised Christ. Van Eyck has only briefly indicated the sky above the landscape

that is running towards the low horizon in such a modern manner. In this way the landscape becomes unbounded and seems to extend across the entire sheet.

Similarly distinguished by the modernity of their design are the miniatures attributed to Jan van Eyck in the destroyed section of the *Turin-Milan Hours*. One of the most impressive was undoubtedly the *Arrest of Christ* at the beginning of the Office of the Passion, which van Eyck staged dramatically by candlelight in the depths of night and with Jerusalem silhouetted in the background. The remarkable illustration of *The Miracle in the Storm* (p. 7) at the "incipit" of the prayer of SS Julian and Martha ranks amongst van Eyck's most important achievements as a landscape painter.

The identification of these miniatures as early works by Jan van Eyck was based primarily on the fact that their figural style leans clearly towards the International Gothic, despite the fact that the same figural types also dominate van Eyck's later panel paintings. The inclusion, within a mysterious beach scene, of the coat of arms of the Wittelsbach rulers of Holland-Hainault seemed further to imply that the miniatures in question were executed during van Eyck's service under the Count of Holland. The problematical fact that the coat of arms is depicted in mirror image, however, rules out any concrete connection with the court at The Hague. There is no further evidence to support an early dating of this miniature, whose motifs contain clear echoes of the horsemen in *The Ghent Altar* (p. 18).

A decisive argument for a late dating of the Eyckian miniatures is provided, lastly, by the old-fashioned miniatures executed by Hand G, which in some

Italian copy after Jan van Eyck
The Crucifixion, early 1500s
Oil on panel, 45 x 30 cm
Padua, Museo d'Arte Medievale e Moderna

The Crucifixion panel (p. 85) by a member of van Eyck's workshop reached Italy before the end of the 15th century. It was copied shortly afterwards by an anonymous Italian painter in the Venice area. This copy was left unfinished, however.

ILLUSTRATION PAGE 85:
Workshop of Jan van Eyck
The Crucifixion, c. 1445
Oil on panel, 46 x 31 cm
Venice, Galleria Franchetti alla Ca' d'Oro

sources were erroneously attributed to Hubert van Eyck. They are distinguished by their heterogeneity, which is indebted to several masters, none of them active before the mid-1430s. *The Discovery of the True Cross* (p. 83 right) is the only surviving miniature from this group. The main picture, executed by a professional illuminator, is inconceivable without a prior knowledge of Eyckian panels. The figures are archaic in style and resemble a drawing of the *Adoration of the Magi* (p. 89) that was formerly thought to be the work of Jan van Eyck, but which is now attributed to a Utrecht master.

The burnt miniature of the *Virgo inter Virgines* (p. 80 right) was also attributed to Hubert van Eyck and given an early date on the basis of its figural style,

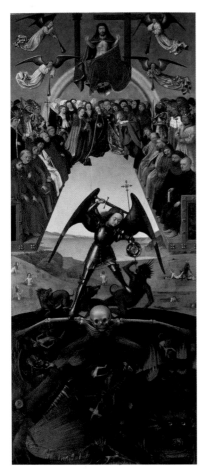

Petrus Christus
Last Judgement (wing of an altarpiece), 1452
Oil on panel, 134 x 56 cm
Berlin, Staatliche Museen zu Berlin,
Gemäldegalerie

ILLUSTRATION PAGE 87:
Jan van Eyck and Workshop
Diptych of the Crucifixion and the Last Judgement, c. 1440
Oil on canvas (transferred from panel), each
56.5 x 19.7 cm
New York, The Metropolitan Museum of Art.
Fletcher Fund, 1933 (33.92 a, b)

The diptych, which was destined for private
worship, combines the Crucifixion with the Last
Judgement. The figure of Christ in Judgement
is painted in a technique different to van Eyck's
own and can probably be attributed to a minia-
turist. It is probable that this work, too, was left
unfinished on the master's death.

which appeared to be still tied to the International Gothic. The main picture
is stylistically ambivalent: the old-fashioned Virgin is accompanied by motifs
resembling panels by Petrus Christus that were not painted before 1445.

There are many reasons for placing Jan van Eyck's activities as a manuscript
illuminator to the latter years of his life. These include not only the stylistic
proximity of his miniatures to his small-scale Marian panels, but also their
technique. All the miniatures attributed to Jan himself demonstrate a technique
unusual for an illuminator, suggesting limited experience in this medium. Had
Jan van Eyck already been illuminating manuscripts for many years, one would
expect him to be more familiar with the peculiar techniques of the genre. Finally,
had he been concentrating upon the illumination of the *Turin-Milan Hours* for
longer, his contribution would surely have been more substantial. This was not
the case, however, as the numerous miniatures by his assistants and followers
show. The fact that the contributors to the *Turin-Milan Hours* included so many
comparatively middling artists lends further weight to the argument that van
Eyck died before the manuscript was complete and that his posthumous work-
shop had to rely increasingly on the assistance of third parties.

Members of the posthumous workshop who are identifiable in paintings
can also be found in certain miniatures: the painter of *St Jerome in his Study*
(p. 78), for example, can be recognized in the miniature of *St Thomas Aquinas*
(p. 80 left), while the painter of the smaller version of *St Francis Receiving the
Stigmata* (p. 77) may have also illuminated *The Agony in the Garden* (p. 81).

The *Turin-Milan Hours* also includes miniatures that go back to lost composi-
tions by Jan van Eyck. One example is *The Crucifixion* miniature (p. 83 left); it
resembles a *Crucifixion* that was produced by Jan van Eyck's posthumous work-
shop (p. 85) and found its way to Veneto at an early stage. While the panel paint-
ing and the miniature do not seem to be directly related, they evidently both go
back to a lost prototype by Jan van Eyck. The original may have resembled the
Crucifixion on the left wing of the so-called *New York Diptych* (p. 87), a late com-
position upon which the workshop probably collaborated and which may in
turn have taken up earlier versions of the subject by the master.

The *New York Diptych* undoubtedly occupies a key position within the discus-
sion surrounding the continuation of the Bruges workshop after Jan van Eyck's
death. Its two wings depict the *Crucifixion* and *Last Judgement*, both of which
were transferred from panel to canvas in the 19th century. On the basis of their
proximity to the miniatures of the *Turin-Milan Hours* and their narrative com-
ponents, the two paintings were sometimes assigned to van Eyck's early œuvre,
but in fact they probably were also produced late on in his career.

The small diptych was, no doubt, destined for private worship. It combines
two central events in the history of Christian salvation, complemented by quota-
tions from Isaiah and Revelation around the gilt frame, and thereby invites the
viewer to reflect upon the significance of Christ's sacrifice on the Cross as a
prerequisite of redemption at the Last Judgement. It is unknown who commis-
sioned the diptych, but the biblical verses in Latin, the golden frame and the
quality of the paintings themselves, whose wealth of magnificent detail calls to
mind the reliquary art of the Middle Ages, seem to assume a donor with sophis-
ticated tastes, and one who must have been familiar with the Latin language in
order to be able to understand the cross-references between the picture and the
inscriptions. Just as van Eyck boldly exploited the predetermined format of the
Turin-Milan Hours to his own ends, so the *Crucifixion* skilfully adapts to the
oblong format dictated by the *Last Judgement*. The *Crucifixion* is conceived in

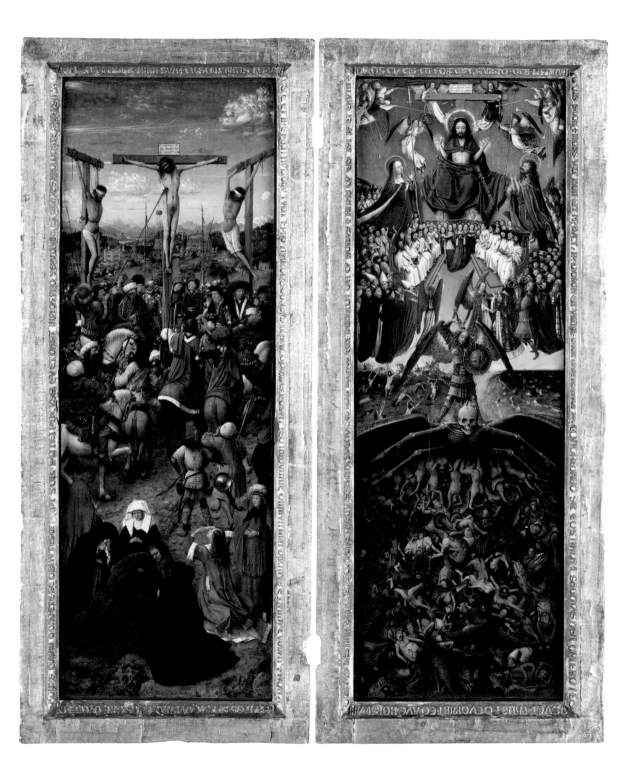

horizontal planes identifying different moments of the Passion and combining them into a continuous narrative. Thus the left-hand foreground is occupied by the group of grieving women around the Virgin and St John the Evangelist, followed on the right by the kneeling figure of Mary Magdalene. Standing on the right-hand edge of the painting, beyond the distraught Mary Magdalene, is one of the sibyls who prophesied not only the death of Christ but also his Resurrection. The soldiers seen from behind invite the viewer to look more closely at the main focus of the composition. The figures of the mourners in the foreground are thereby reflected on the shield. Above the soldiers, a company of horsemen arriving from the left has gathered around the Cross. The riders resemble the *Soldiers of Christ* and the *Righteous Judges* in *The Ghent Altarpiece* (p. 18), but are here lent greater dynamism by being seen in rear view. The Crucifixion group rises above the crowd and presents its own, self-contained moment within the narrative: the piercing of Christ's side with the lance. The artist has incorporated a view of Jerusalem in the background and in depicting the Dome of the Rock has taken pains to achieve topographical accuracy; at the same time, the viewer's gaze is drawn beyond the city to a magnificent, atmospheric landscape universe with a river winding through it and in the distance the snow-capped peaks of a mountain range.

A significant element of the design is its large number of figures seen in rear view, an artistic device undoubtedly meant to steer the viewer's gaze towards the Crucifixion. In this respect it recalls Eyckian miniatures such as the *Birth of St John the Baptist* and the *Mass of the Dead* (p. 82), in which figures seen from behind also assume an important dramatic function.

A striking feature of the *Last Judgement* is its strict horizontal division, which separates the lower zone, with its depiction of Hell, from the upper zone containing Christ in Judgement. In the middle, the artist depicts the Resurrection of the dead. This narrow earthly zone rests literally on the wings of the personification of Death, beneath which van Eyck details the torments of Hell suffered by the damned. Standing on Death's shoulders is the Archangel Michael. In his golden armour he resembles his counterpart in the Dresden *Triptych of the Virgin and Child* (pp. 56–57). The upper zone depicts the deësis group around Christ in Judgement, at whose feet are the considerably smaller figures of the elders, saints and beatified. Angels hovering around the figure of God hold up the instruments of Christ's Passion.

It has long since been noticed that the depiction of Christ in Judgement and the saints falls short of the painterly sophistication of the *Crucifixion* and the portrayal of Hell. The upper zone of the *Last Judgement* is indeed executed in a different manner to the rest of the painting and in its additive handling of surfaces employs a technique closely related to manuscript illumination. Although it is impossible to link the heavenly zone with one of the miniaturists of the *Turin-Milan Hours*, the relationship between manuscript and diptych is more than clear. Was the composition left unfinished in the workshop upon van Eyck's death, or was the task of executing the painting – based on a design conceived by van Eyck himself – shared right from the start among several assistants? Whatever the case, its close relation to the codex confirms the late date of the diptych. For Petrus Christus studied the painting while it was still in van Eyck's workshop, and in 1452 paraphrased its depiction of the *Last Judgement* in the wing of a monumental altarpiece commissioned for a Spanish convent (p. 86).

A decade after the death of Jan van Eyck, the fame of the Burgundian court painter had spread across Europe. His works had become coveted treasures

ILLUSTRATION PAGE 88:
Copy after Jan van Eyck
Woman at her Toilette, c. 1500
Oil on panel, 27.5 x 16.4 cm
Cambridge, MA, Harvard University Art Museums, Fogg Art Museum. Francis H. Burr, Louise Haskell Daly, Alpheus Hyatt Purchasing and William M. Prichard Funds, 1969.83

This scene of a naked woman at her toilette is set within an interior reminiscent of the *Arnolfini Marriage* (p. 45). Van Eyck's lost original was housed in the 17th century in the Antwerp art collection of Cornelis van der Gheest. It is a rare example of a secular subject within the artist's œuvre.

Workshop of Jan van Eyck
Adoration of the Magi, c. 1435–1440
Pen and brush on parchment, 15.2 x 12.3 cm
Berlin, Staatliche Museen zu Berlin, Kupferstichkabinett

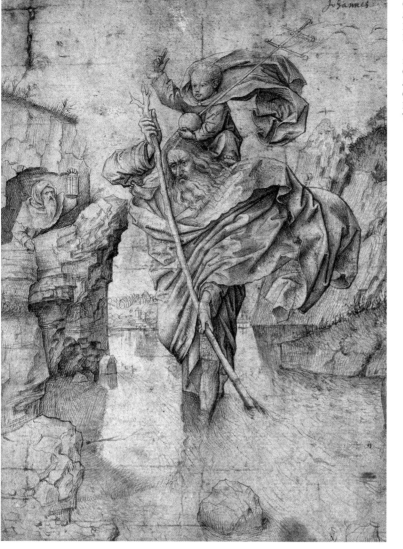

Copy after Jan van Eyck
St Christopher, c. 1480–1490
Pen and brush on paper, 19 x 14 cm
Paris, Musée du Louvre

ILLUSTRATION PAGE 91:
Copy after Jan van Eyck
St Christopher, c. 1460–1480
Oil on panel, 29.5 x 21.1 cm
Philadelphia, PA, Philadelphia Museum of Art.
The John G. Johnson Collection

that the princes of southern Europe, above all Alfonso V of Aragon in Naples, sought to garner for their collections. The innovations that Jan van Eyck brought to art – not solely the secret of oil painting – inspired artists on the Iberian Peninsula, in Italy, France and central Europe, and paved the way to international success for his followers in Flanders, above all Petrus Christus and Hans Memling. Right up to today, the fame of *Johannes arte secundus* – John, second in the art – continues to exceed that of his brother Hubert, who died so early on, and overshadows the considerable contribution of Lambert van Eyck, who was probably largely in charge of the posthumous production of the Bruges workshop.

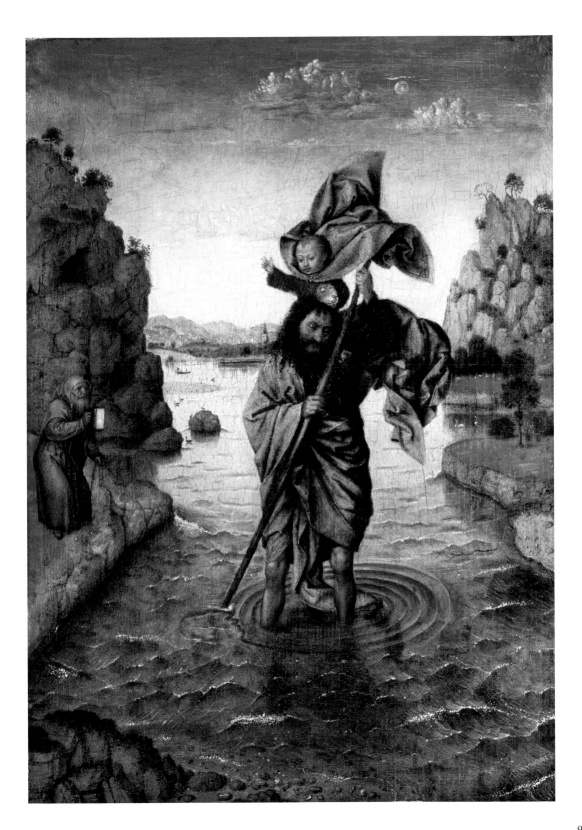

Jan van Eyck
Chronology

c. 1380–1385 Hubert van Eyck is born probably in Maaseyck.

1384 Following the death of Lodewijk van Maele, his son-in-law Philip the Bold, Duke of Burgundy, becomes Count of Flanders.

c. 1390 Jan van Eyck is born probably in Maaseyck.

1409 Master Hubert paints an altarpiece for the nunnery in Tongeren.

1419 Philip the Good, the third Duke of Burgundy, ascends the throne of Flanders.

c. 1420 The Ghent patrician Joos Vijd commissions Hubert van Eyck to paint *The Ghent Altarpiece* (chap. 2).

1422 Jan van Eyck is employed as a painter in the service of John of Bavaria-Straubing, who since 1418 rules the counties of Holland and Zeeland. Together with his assistants, Jan van Eyck presumably works on decorations of the "Binnenhof", the royal palace in The Hague.

1424 Jan van Eyck is mentioned in Holland's treasury accounts for the first time as a court painter, although he has probably already held this position for a while.

1425 Following the death of John of Bavaria on 6 January, Jan van Eyck moves to Bruges. A document issued there on 19 May appoints him as court artist to the Duke of Burgundy, Philip the Good. In the summer Jan van Eyck moves to Lille and at Christmas receives his first year's salary as valet de chambre to the Duke.

1426 In August the Burgundian treasury in Lille pays Jan van Eyck for two journeys undertaken for Philip the Good. The first was a pilgrimage that he made on the Duke's behalf and that may have taken him via Italy to the Holy Land. The second journey was secret and took the painter to "distant lands" that – according to the records – were not to be named: probably cities in the Ottoman Empire. In October Jan van Eyck is again reimbursed for travel expenses for a "secret and distant journey" undertaken at the Duke's request.

1427 The Burgundian treasury in Lille awards Jan van Eyck various payments for his services at court. On the Feast of St Luke, he attends a banquet hosted by the painters' guild in Tournai, at which Robert Campin and Rogier van der Weyden are also present. The Tournai corporation welcomes the artist on this occasion with wine of honour.

1428 On 23 March Jan van Eyck is back in Tournai. In spring, the Lille treasury pays the painter a bonus on top of his annual salary. In the summer he is again reimbursed for "certain

HVBERTO AB EYCK, IOANNIS FRATRI, PICTORI.
Quas modo commune cum fratre, Huberte, meronti
Attribuit laudes nostra Thalia tibi,
Si non sufficient: addatur et illa tua quod
Discipulus frater te superant ope.
Hoc vestrum docet illud opus Gandenso Philippum
Quod Regem tanto cepit amore sui.
Eius ut ad patrios mittendum exemplar Iberos
+ Coxonni fiori iufferit ille manu.
+ Michael Coxennus Machlin.
um insignis hac atate pictor

secret journeys". In the same summer, Jan van Eyck moves out of his house in Lille and at the end of the year accompanies a high-ranking Burgundian delegation via England and Galicia to Portugal, where the marriage of Philip the Good and the Portuguese infanta Isabella is negotiated. Amongst the Burgundian diplomats on this trip is Baudouin de Lannoy (p. 39).

1429 In Portugal Jan van Eyck paints two portraits of the princess, which are sent back to the Duke in February. While waiting for a response, a number of Burgundians, probably including van Eyck, make a pilgrimage to Santiago di Compostela and meet King Juan II of Castile, as well as Mohammed, King of Granada. In September the bride and her retinue set sail for the Netherlands, where they arrive at Christmas at Sluis, one of the ports of Bruges.

1431 Lambert van Eyck is paid for services to the Duke.

1432 On 6 May *The Ghent Altarpiece* is inaugurated in the Sint Janskerk (today St Bavo's Cathedral). Shortly after – at the latest – the artist settles permanently in Bruges and establishes a workshop. He will make mortgage repayments on his house to St Donatian's

IOANNES AB EYCK PICTOR.

Ille ego, qui lætos oleo de semine lini
Expreſſo docui princeps miſcere colores,
Huberto cum fratre· nouum ſtupuëre repertum,
Atque ipſi ignotum quondam fortaſſis Apelli,
Florentes opibus Brugæ· mox noſtra per omnem
Diffundi latè probitas non abnuit orbem.

Portraits of Jan and Hubert van Eyck from the book *Pictorum aliqot celebrium Germaniae inferioris effigies* (1572) by the Ghent humanist Domenicus Lampsonius. The likenesses are based on two of the *Righteous Judges* in *The Ghent Altarpiece* (p. 95), which in the 16th century were thought to be self-portraits.

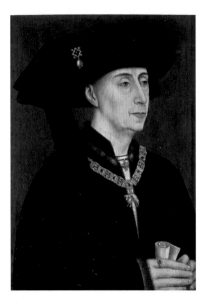

Copy after Rogier van der Weyden
Philip the Good, c. 1550
Oil on panel, 32.5 x 22.4 cm
Bruges, Groeningemuseum

church for the rest of his life. The Bruges councillors and the Duke and his retinuevisit the painter's workshop. Jan van Eyck executes the *Portrait of a Man (Léal Souvenir)* (p. 38). This same year Lambert van Eyck paints the lost *Portrait of Jacoba of Bavaria* (p. 11).

1433 The artist's personal motto, "ALC IXH XAN", appears for the first time on the frame of *A Man in a Turban* (p. 37). Jan van Eyck's marriage to "damoiselle Marguerite" (Margarete van Eyck; p. 36) probably in this year.

1434 At the request of Giovanni Arnolfini, Jan van Eyck paints *The Arnolfini Marriage* (p. 45). This same year he is commissioned to paint the *Madonna of Joris van der Paele* (pp. 54–55) and probably also the *Madonna of Chancellor Nicolas Rolin* (p. 48). Birth of Jan van Eyck's first child, who is christened Philippot or Philippotte after his godfather, Philip the Good. From autumn onwards, van Eyck works for Bruges' city council on the gilding and

polychromy of six stone statues of the Counts of Flanders for the façade of the Town Hall, for which he is paid the following year.

1435 The Duke converts Jan's annual salary into a lifetime pension and substantially increases its amount. He personally instructs the Burgundian treasury to pay his esteemed painter without delay. At the order of Philip the Good, van Eyck travels to the peace congress at Arras in order to portray the participants. There he executes the *Portrait Drawing of Niccolò Albergati* (p. 42). The *Madonna of Chancellor Nicolas Rolin* (p. 48) is probably completed this year.

1436 Completion of the *Madonna of Joris van der Paele* (pp. 54–55) and the *Portrait of Jan de Leeuw* (p. 40). On behalf of the Duke of Burgundy, the painter once again sets off for "foreign lands" in order to conduct "secret business", for which he receives double his annual pay.

1437 Completion of the Dresden *Triptych of the Virgin and Child* (pp. 56–58), a portable altarpiece commissioned by a Genoese merchant. Jan van Eyck starts work on *St Barbara* (p. 65), which will remain unfinished.

1438 Completion of the *Portrait of Niccolò Albergati* (p. 43) and *The Face of Christ*, which survives only in copy (p. 47). Van Eyck pays Jean Creve, a manuscript illuminator in Bruges, for the initials of a codex destined for the Duke; the Lille treasury reimburses the expenses the following year. The initials are probably linked with the decoration, begun by van Eyck and his workshop, of the so-called *Turin-Milan Hours* (pp. 7, 80–83).

1439 Completion of the *Madonna at the Fountain* (p. 67), the *Portrait of Margarete van Eyck* (p. 36).

1440 Jan van Eyck gives the Duke "certain panels and other secret items", for which the Burgundian treasurery pays him the following year. Starts work on the *Madonna of Nicolas van Maelbeke* (unfinished) (p. 75 bottom).

1441 Jan van Eyck dies in July; by way of assistance, the Duke makes the artist's widow a one-off payment to the value of the deceased's annual pension.

1442 Lambert van Eyck obtains permission from the collegiate chapter of St Donatian's to exhume his brother's body and to rebury him inside the church. Completion of *St Jerome in his Study* (p. 78).

1443 Completion of the *Madonna of Jan Vos* (pp. 74–75).

1444 In Bruges, the Valencian merchant Gregori acquires van Eyck's *St George* for the collection of Alfonso V of Aragon.

1449 Cyriacus of Ancona mentions Jan van Eyck as a famous painter.

1450 The artist's daughter enters a convent in Maaseyck. Van Eyck's Bruges house is sold and his workshop disbanded.

1456 Bartolomeo Facio mentions works by Jan van Eyck in Italian collections, including the *Lomellini Triptych* in Naples and a *Women Bathing in Urbino*.

1550 Giorgio Vasari attributes Jan van Eyck with the "invention of oil painting".

The Ghent Altarpiece, open, 1432
Jef van der Veken, after Jan and Hubert van Eyck
The Righteous Judges (detail), c. 1948
Tempera on panel, 146.5 x 51.5 cm
Ghent, St Bavo's Cathedral

In the 16th century, the individualized features of two of *The Righteous Judges* in *The Ghent Altarpiece* were interpreted as hidden portraits of Jan and Hubert van Eyck. Although the figures became the basis of many later "portraits" (pp. 92, 93), their traditional identification rests on no firm evidence. The original panel was stolen in 1934; the present version is a copy.

Bibliography

Baldass, Ludwig von: *Jan van Eyck*. London and New York 1952.

Bauch, Kurt: "Bildnisse des Jan van Eyck", *Jahreshefte der Heidelberger Akademie der Wissenschaften*, 1961–1962.

Borchert, Till-Holger (ed.): *Jan van Eyck und seine Zeit. Flämische Meister und der Süden, 1430–1530*. Stuttgart 2002.

Brine, Douglas: *Piety and Purgatory: Wall-mounted memorials from the southern Netherlands, c. 1380–1520*. PhD University of London 2006.

Brinkman, Pim: *Het Geheim van Van Eyck*. Zwolle 1993.

Bruyn, Josua: *Van Eyck Problemen*. Utrecht 1957.

Buck, Stephanie: "Petrus Christus' Berlin Wings and the Metropolitan Museum's Eyckian Diptych", in: Maryan W. Ainsworth (ed.): *Petrus Christus in Renaissance Bruges*. Turnhout 1995, pp. 65–83.

Buren, Anne H. van: *The Turin-Milan Hours*. Turin, Museo Civico d'Arte Antica Inv. No. 47. Commentary volume to the facsimile, Lucerne 1996.

Campbell, Lorne: *National Gallery Catalogues: The Fifteenth Century Netherlandish Schools*. London 1998.

Châtelet, Albert: *Jean van Eyck enlumineur*. Strasburg 1993.

Coremans, Paul: *L'Agneau Mystique au Laboratoire. Examen et traitment*. Antwerp 1953.

Dhanens, Elisabeth: *Hubert en Jan van Eyck*. Antwerp 1980.

Dvorak, Max: *Das Rätsel der Kunst der Brüder van Eyck*. Munich 1925.

Herzner, Volker: *Jan van Eyck und der Genter Altar*. Worms 1995.

Jones, Susan Frances: "The Use of Workshop Drawings by Jan van Eyck and his Followers", in: Susan Foister (ed.) et al.: *Investigating Jan van Eyck*. Turnhout 2000, pp. 199–207.

Jones, Susan Frances: "New evidence for the date, function and historical significance of Jan van Eyck's 'Van Maelbeke Virgin'", in: *The Burlington Magazine*, 148 (2006), pp. 73–81.

Ketelsen, Thomas and Uta Neidhardt: *Das Geheimnis des Jan van Eyck. Die frühen niederländischen Zeichnungen und Gemälde in Dresden*. Munich and Berlin 2005.

König, Eberhard: *Die Très Belles Heures von Jean de France, Duc de Berry*. Munich 1998.

Koreny, Fritz (ed.): *Altniederländische Zeichnungen von Van Eyck bis Hieronymus Bosch*. Antwerp 2002.

Koster, Margaret L.: "The Arnolfini double portrait: A simple solution", in: *Apollo*, 499 (September 2003), pp. 3–14.

Lorentz, Philippe: "The Virgin and Chancellor Rolin and the Office of Matins", in: Susan Foister et al. (ed.): *Investigating Jan van Eyck*. Turnhout 2000, pp. 49–58.

Pächt, Otto: *Van Eyck. Die Begründer der altniederländischen Malerei*. Munich 1989.

Panofsky, Erwin: *Early Netherlandish Painting. Its Origins and Character*. Cambridge (MA) 1953.

Paviot, Jacques: "La vie de Jan van Eyck selon les documents écrits", in: *Revue des Archéologues et Historiens de l'art de Louvain*, 23 (1990), pp. 83–93.

Preimesberger, Rudolf: "Zu Jan van Eycks Diptychon der Sammlung Thyssen-Bornemisza", in: *Zeitschrift für Kunstgeschichte* 54 (1991), pp. 459–489.

Purtle, Carol J.: *The Marian Paintings of Jan van Eyck*. Princeton 1982.

Reynolds, Catherine: "The King of Painters", in: Susan Foister et al. (ed.): *Investigating Jan van Eyck*. Turnhout 2000, pp. 1–16.

Snyder, James: "The Chronology of Jan van Eyck's Paintings", in: *Album Amicorum J. G. van Gelder*. The Hague 1973, pp. 293–297.

Sterling, Charles: "Jan van Eyck avant 1432", in: *Revue de l'Art*, 33 (1976), pp. 7–82.

Weale, W. H. James: *Hubert and John van Eyck. Their life and work*. London 1908.

Photo Credits